Audition Songs
Male Singers 2

Wise Publications
London/New York/Paris/Sydney/Copenhagen/Madrid

Exclusive Distributors:
Music Sales Limited
8-9 Frith Street,
London W1V 5TZ, England.
Music Sales Pty Limited
120 Rothschild Avenue,
Rosebery, NSW 2018,
Australia.

Order No. AM950213
ISBN 0-7119-7010-6
This book © Copyright 1997 by Wise Publications

Compiled by Paul Honey and Jack Long
New arrangements by Jack Long
Music processed by Enigma Music Production Services

CD performed and recorded by Paul Honey

Book design by Studio Twenty, London

Printed in the United Kingdom by
Caligraving Limited, Thetford, Norfolk.

Your Guarantee of Quality
As publishers, we strive to produce every book
to the highest commercial standards.
The music has been freshly engraved and the book has been
carefully designed to minimise awkward page turns and
to make playing from it a real pleasure.
Particular care has been given to specifying acid-free,
neutral-sized paper made from pulps which have not been
elemental chlorine bleached. This pulp is from farmed sustainable
forests and was produced with special regard for the environment.
Throughout, the printing and binding have been planned to ensure a
sturdy, attractive publication which should give years of enjoyment.
If your copy fails to meet our high standards, please inform us and
we will gladly replace it.

Music Sales' complete catalogue describes thousands of
titles and is available in full colour sections by subject, direct
from Music Sales Limited. Please state your areas of interest and
send a cheque/postal order for £1.50 for postage to:
Music Sales Limited, Newmarket Road, Bury St. Edmunds,
Suffolk IP33 3YB.

All I Need Is The Girl

Music by Jule Styne
Words by Stephen Sondheim

Bright (♩ = 98)

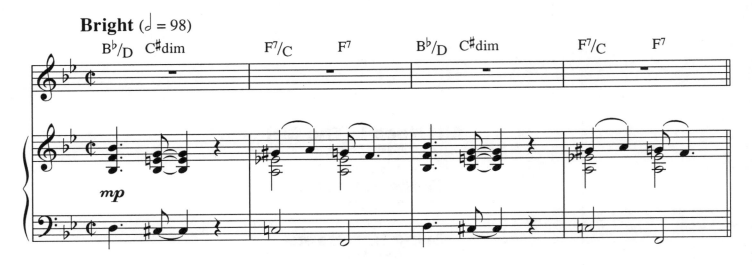

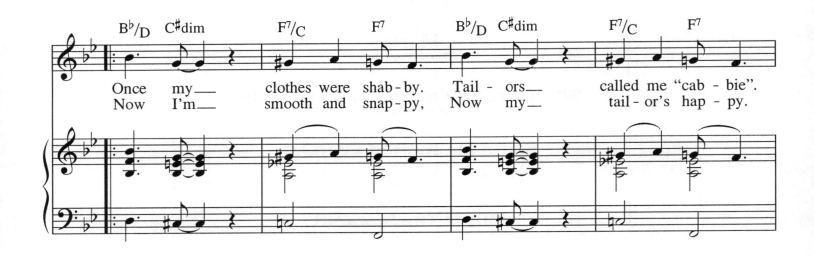

Once my___ clothes were shab-by. Tail-ors___ called me "cab-bie".
Now I'm___ smooth and snap-py, Now my___ tail-or's hap-py.

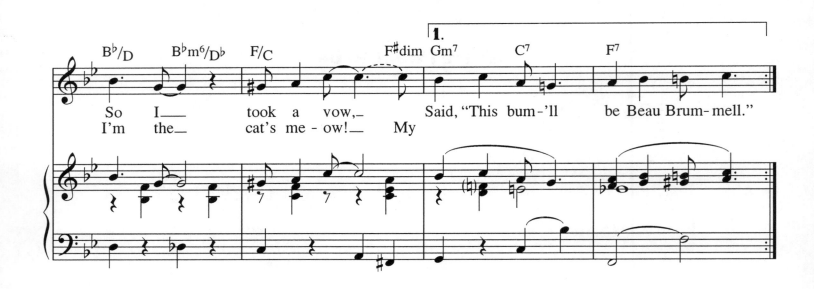

1.

So I___ took a vow,___ Said, "This bum-'ll be Beau Brum-mell."
I'm the___ cat's me-ow!___ My

4

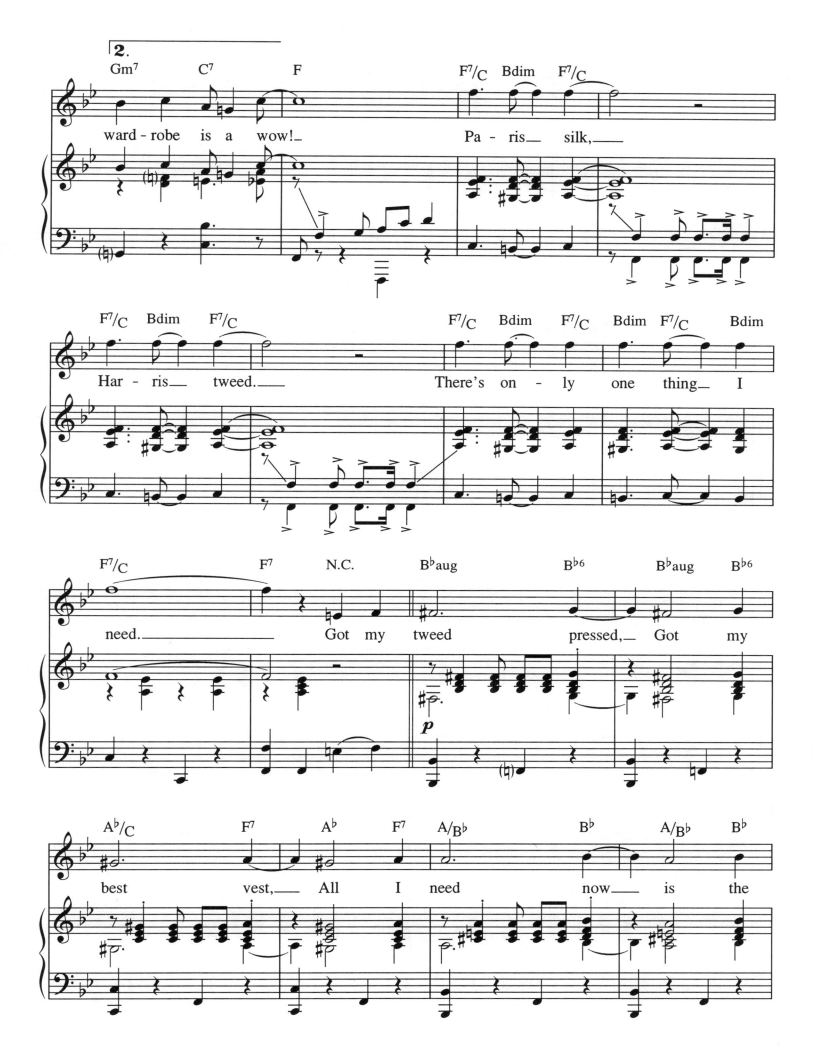

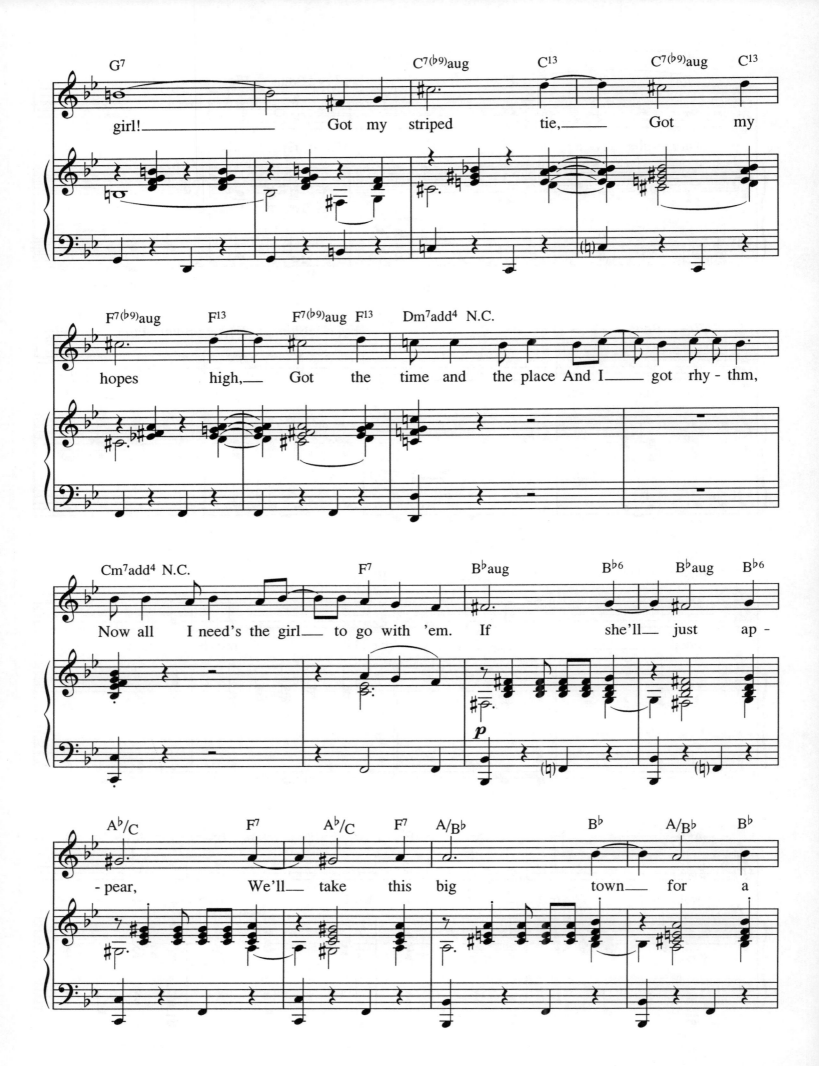

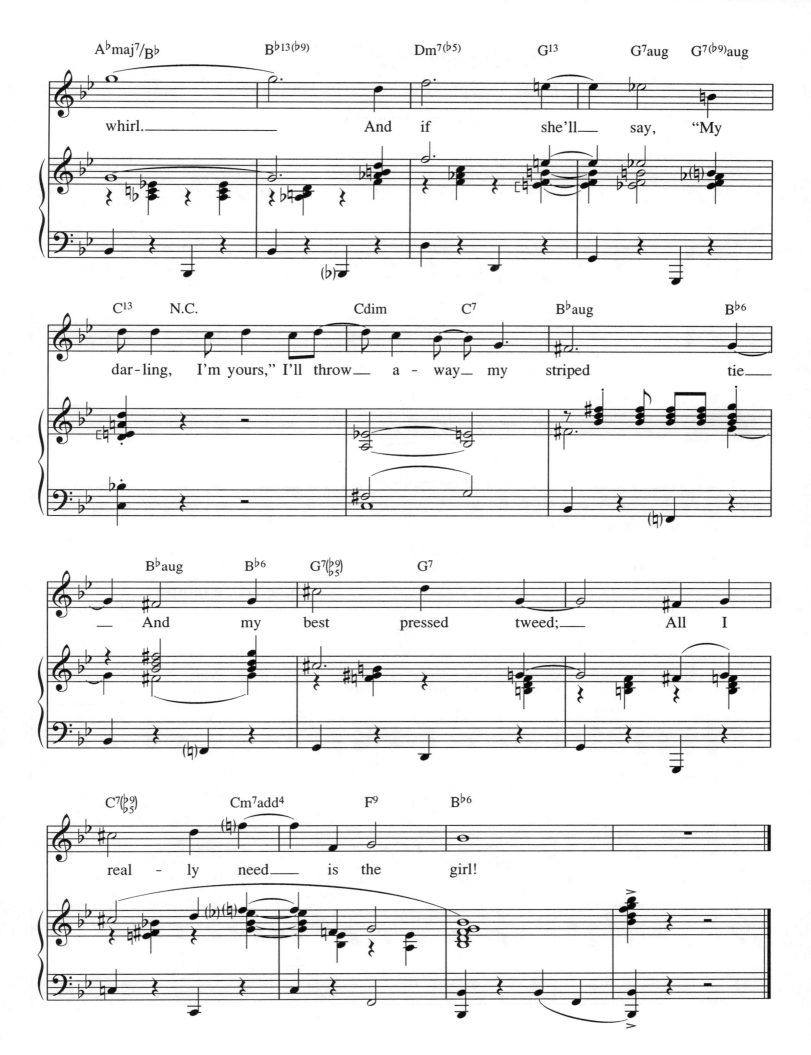

Frederick's Aria

By W. S. Gilbert & Sir Arthur Sullivan

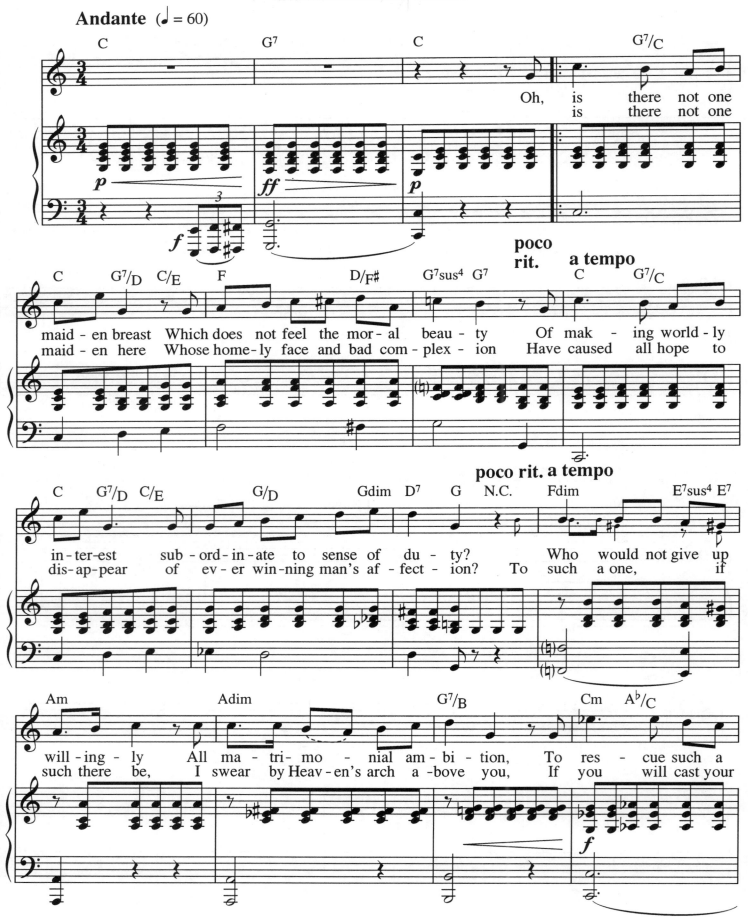

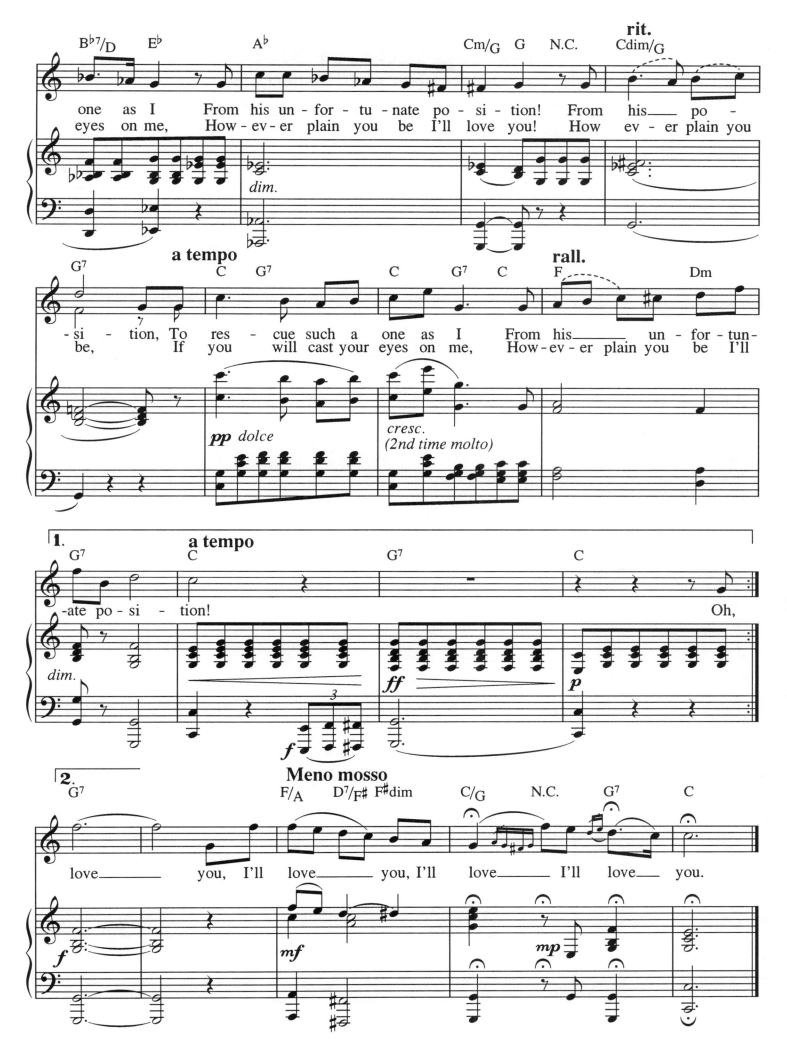

Bring Him Home

Music by Claude-Michel Schönberg
Lyrics by Herbert Kretzmer & Alain Boublil

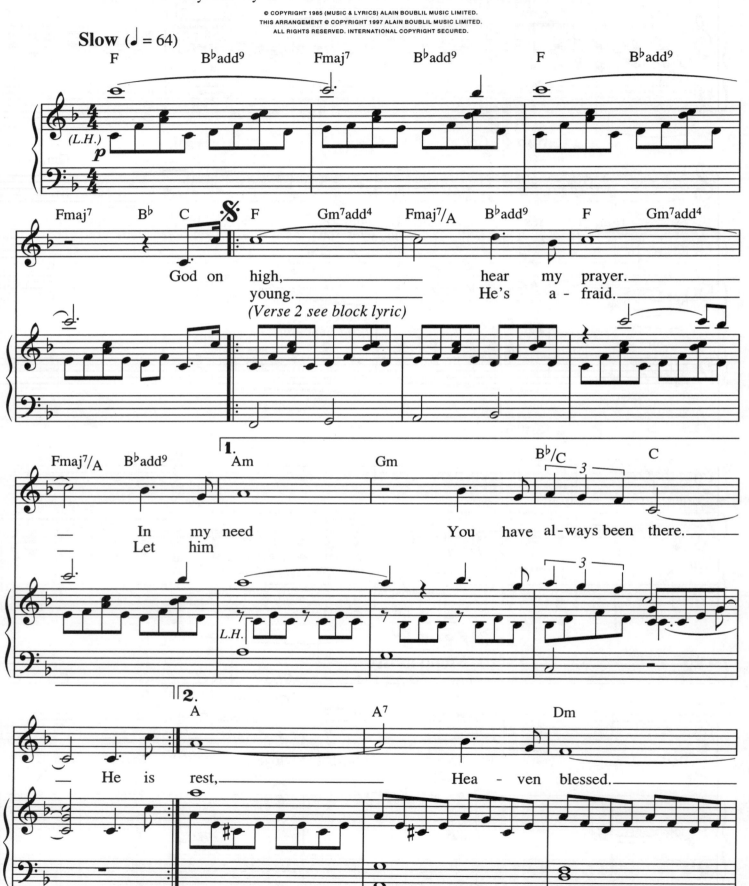

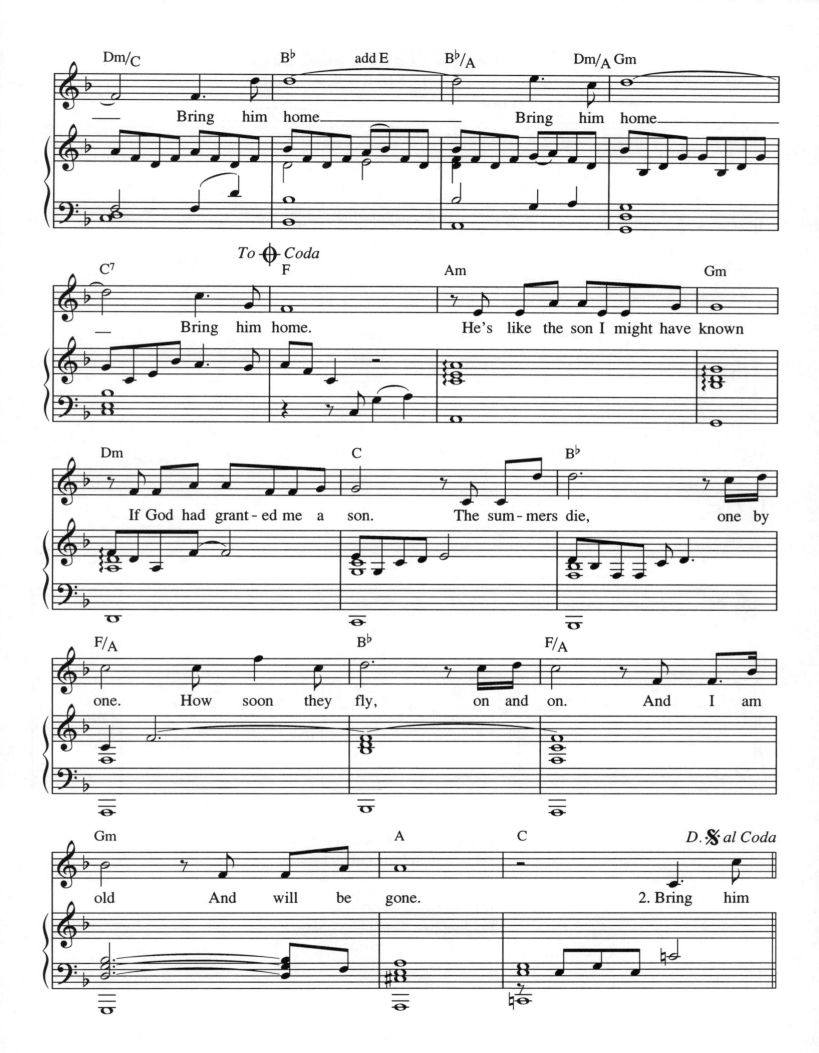

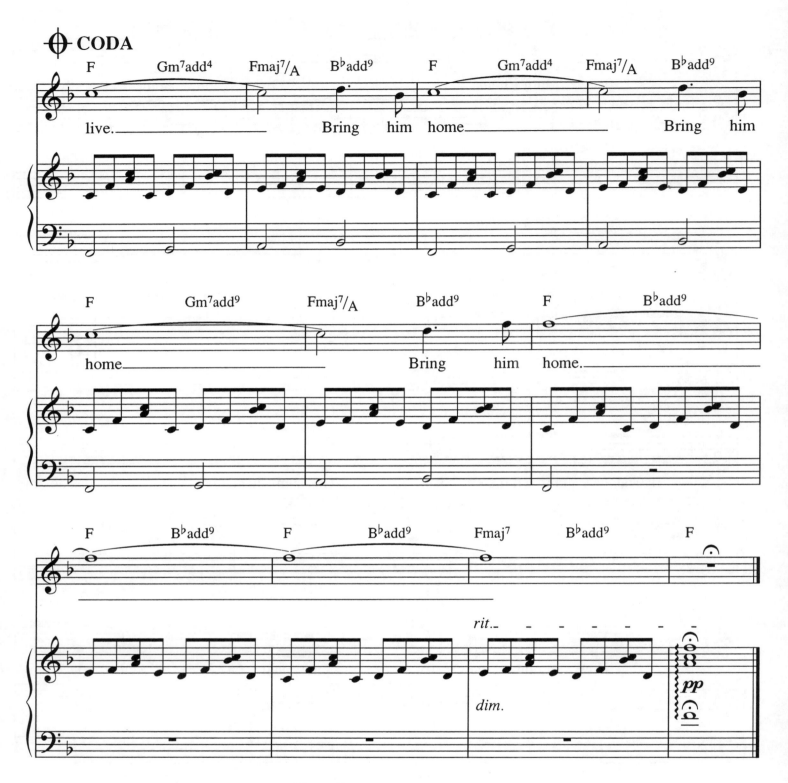

Verse 2
Bring him peace, bring him joy.
He is young, he is only a boy.
You can take it. You can give.
Let him be. Let him live.
If I die, let me die.
Let him live. Bring him home,
Bring him home. Bring him home.

I Don't Remember Christmas

Music by David Shire
Words by Richard Maltby Jr.

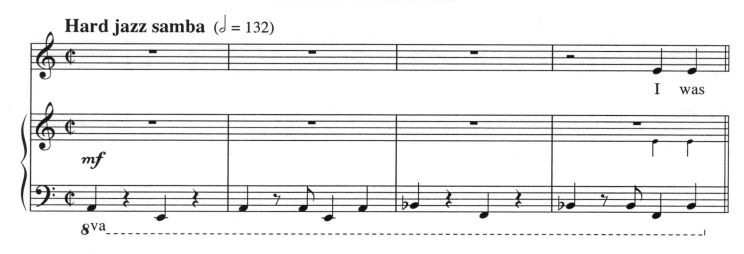

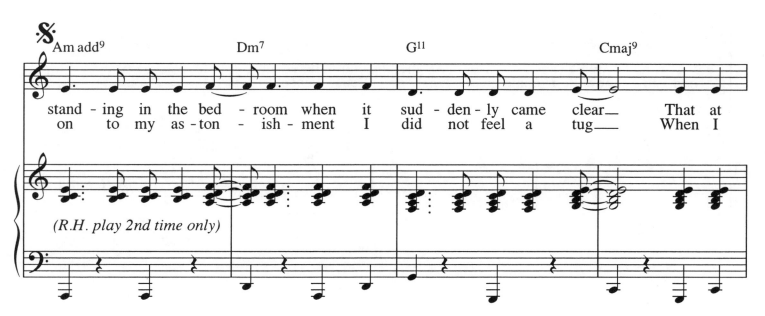

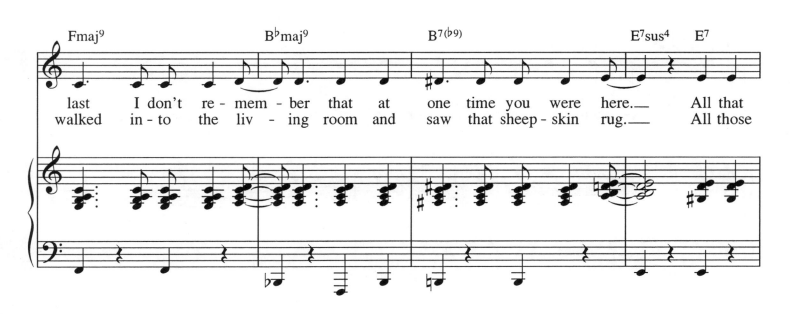

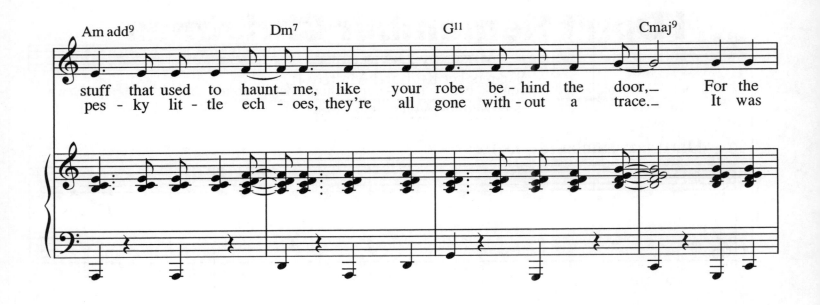

stuff that used to haunt me, like your robe be-hind the door,__ For the
pes-ky lit-tle ech-oes, they're all gone with-out a trace.__ It was

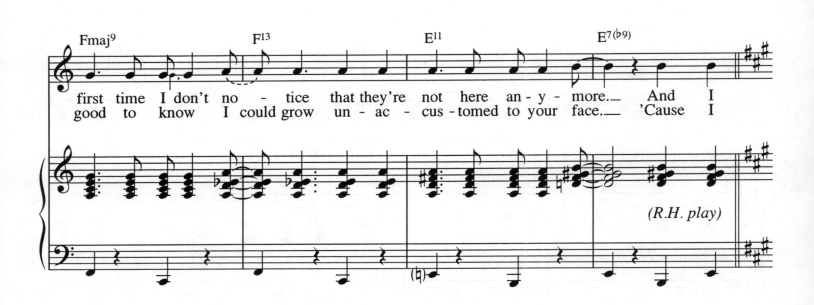

first time I don't no-tice that they're not here an-y-more.__ And I
good to know I could grow un-ac-cus-tomed to your face.__ 'Cause I

(R.H. play)

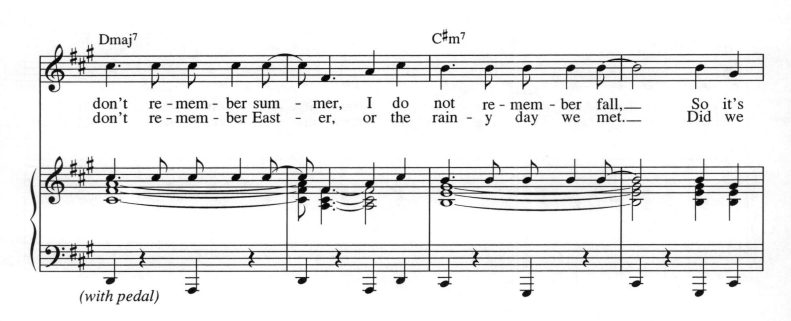

don't re-mem-ber sum-mer, I do not re-mem-ber fall,__ So it's
don't re-mem-ber East-er, or the rain-y day we met.__ Did we

(with pedal)

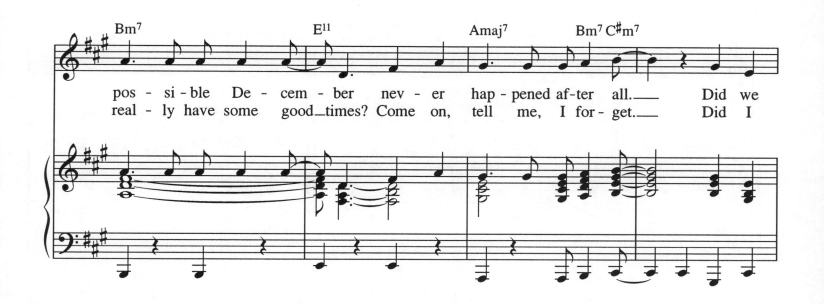

pos - si - ble De - cem - ber nev - er hap - pened af - ter all.___ Did we
real - ly have some good___times? Come on, tell me, I for - get.___ Did I

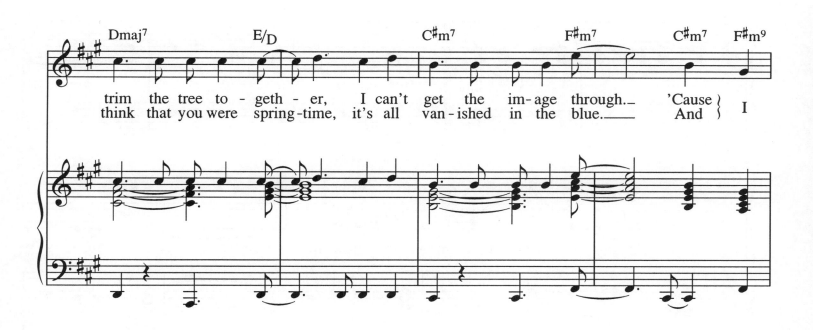

trim the tree to - geth - er, I can't get the im - age through.___ 'Cause } I
think that you were spring - time, it's all van - ished in the blue.___ And } I

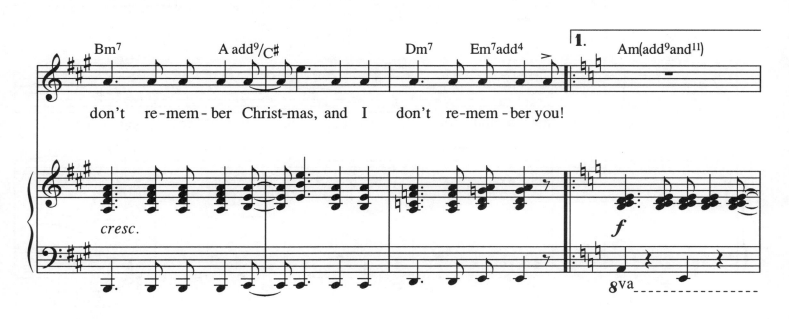

don't re - mem - ber Christ - mas, and I don't re - mem - ber you!

cresc.

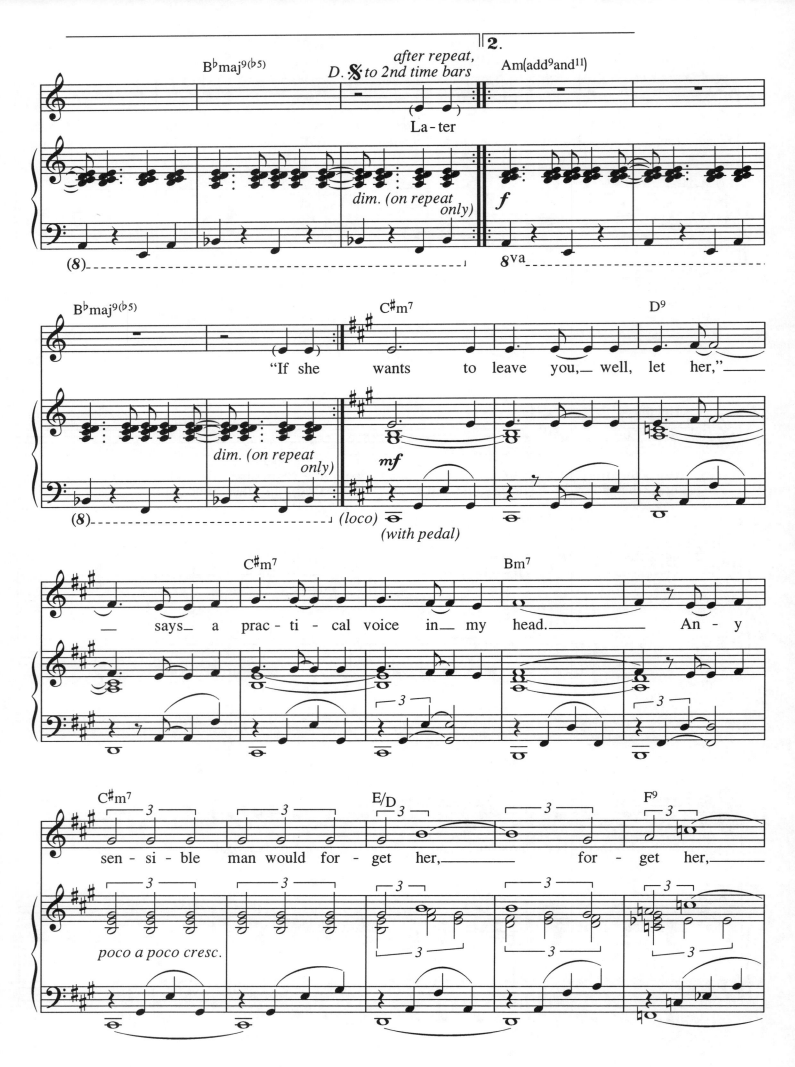

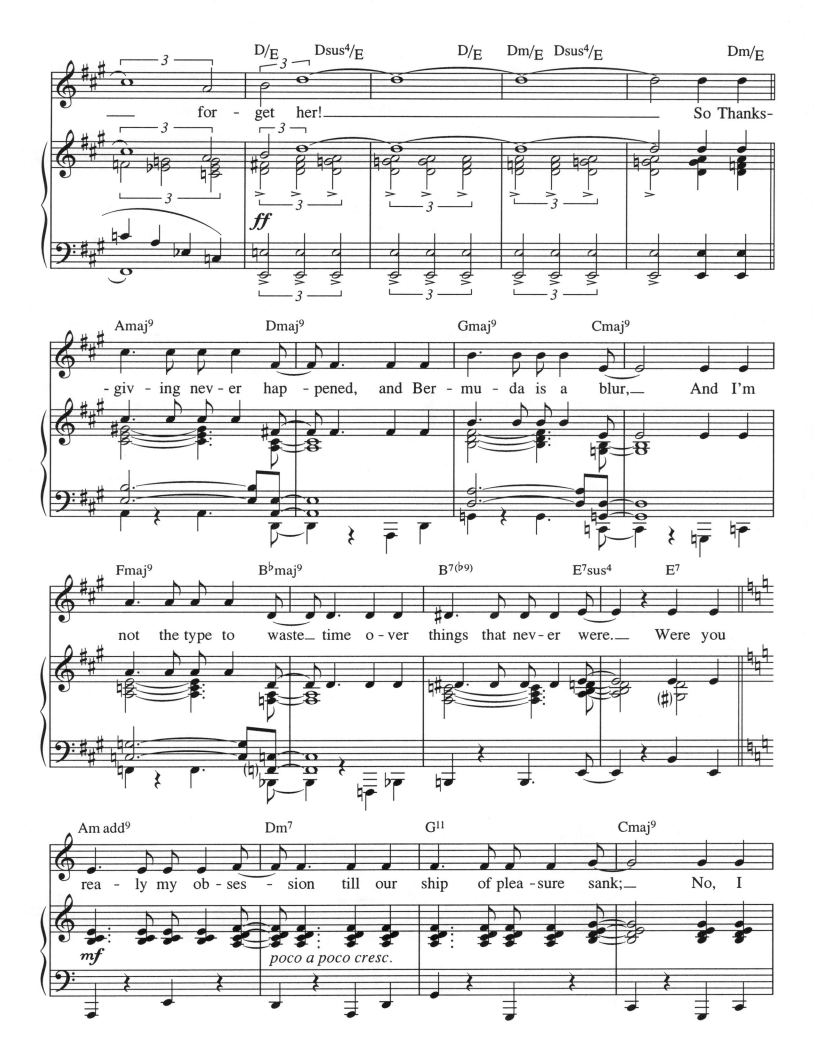

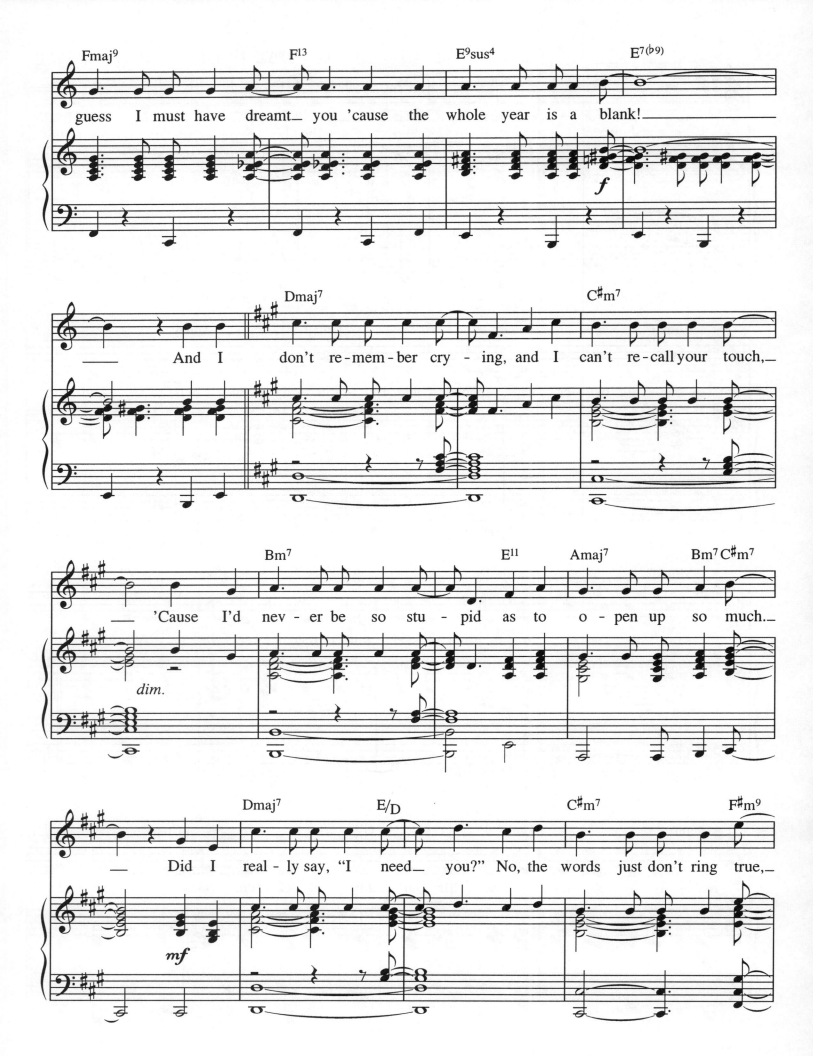

guess I must have dreamt_ you 'cause the whole year is a blank!_____

_____ And I don't re-mem-ber cry - ing, and I can't re-call your touch,_

_____ 'Cause I'd nev-er be so stu-pid as to o-pen up so much._

_____ Did I real-ly say, "I need_ you?" No, the words just don't ring true,_

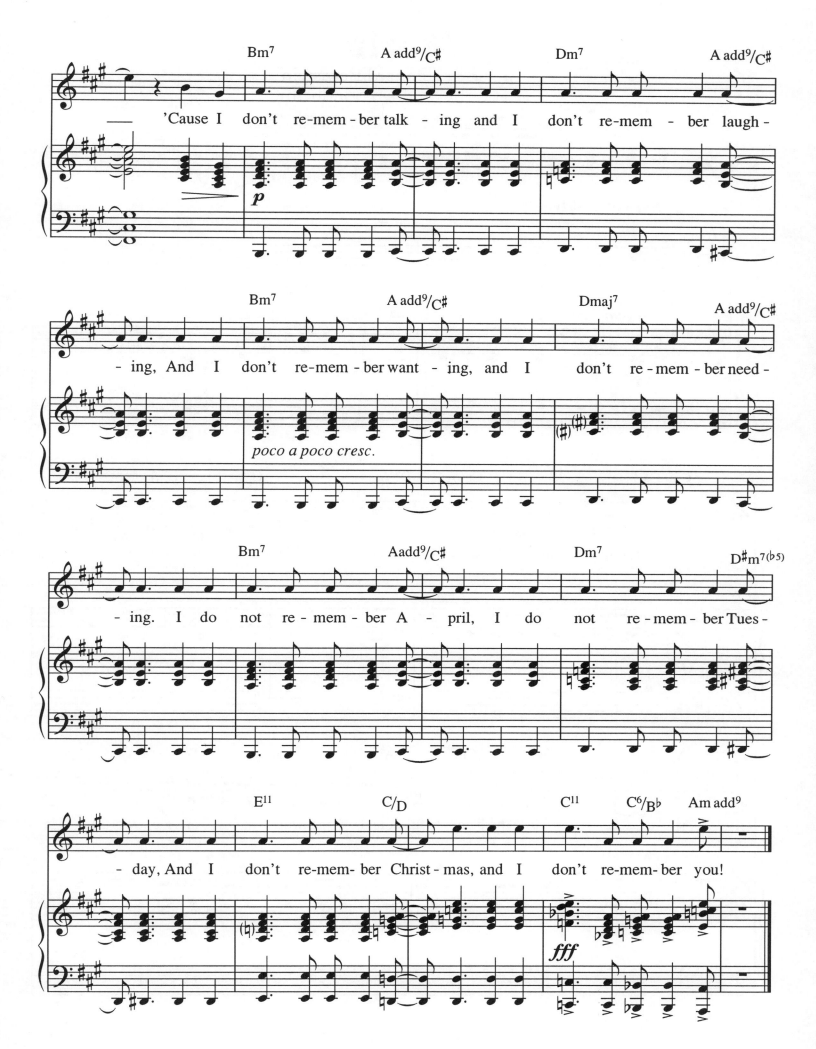

Maria

Music by Leonard Bernstein
Lyrics by Stephen Sondheim

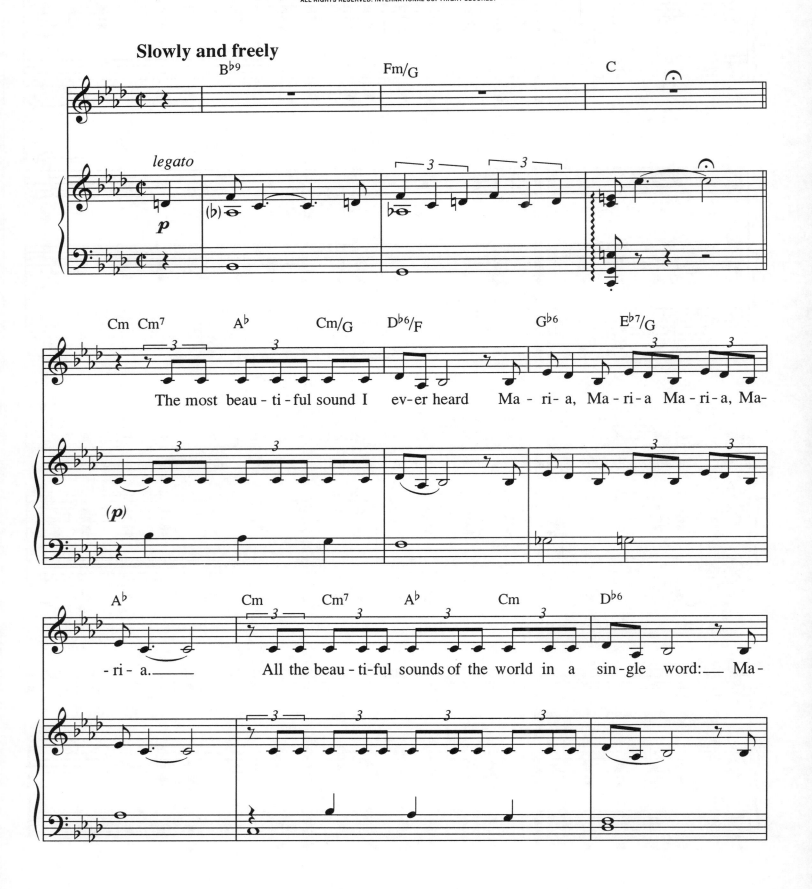

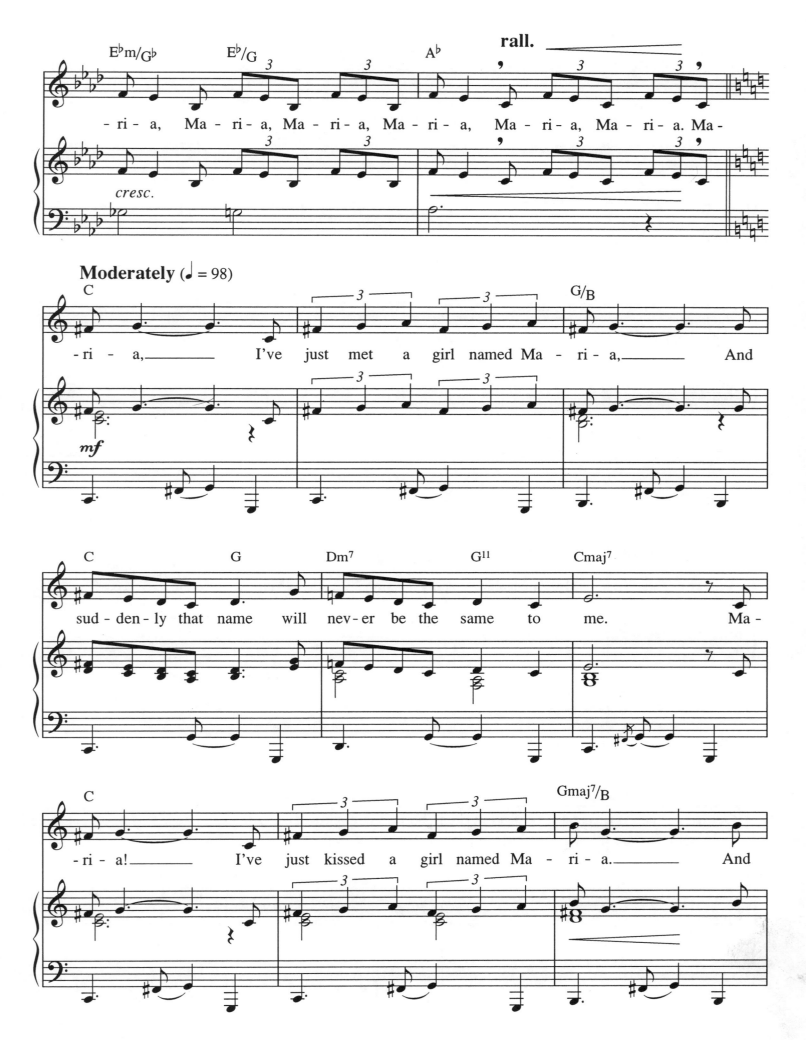

-ri - a, Ma - ri - a, Ma - ri - a, Ma - ri - a, Ma - ri - a, Ma - ri - a. Ma-

Moderately (♩ = 98)

-ri - a,_____ I've just met a girl named Ma - ri - a,_____ And

sud - den - ly that name will nev - er be the same to me. Ma-

-ri - a!_____ I've just kissed a girl named Ma - ri - a._____ And

21

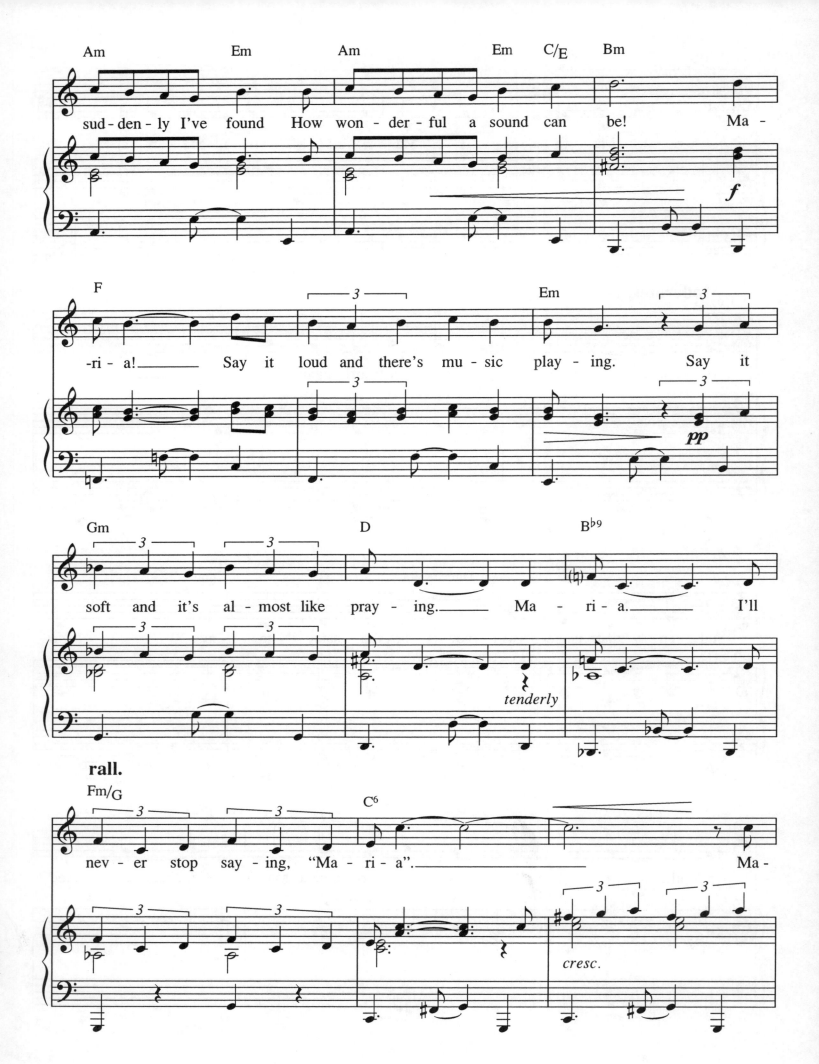

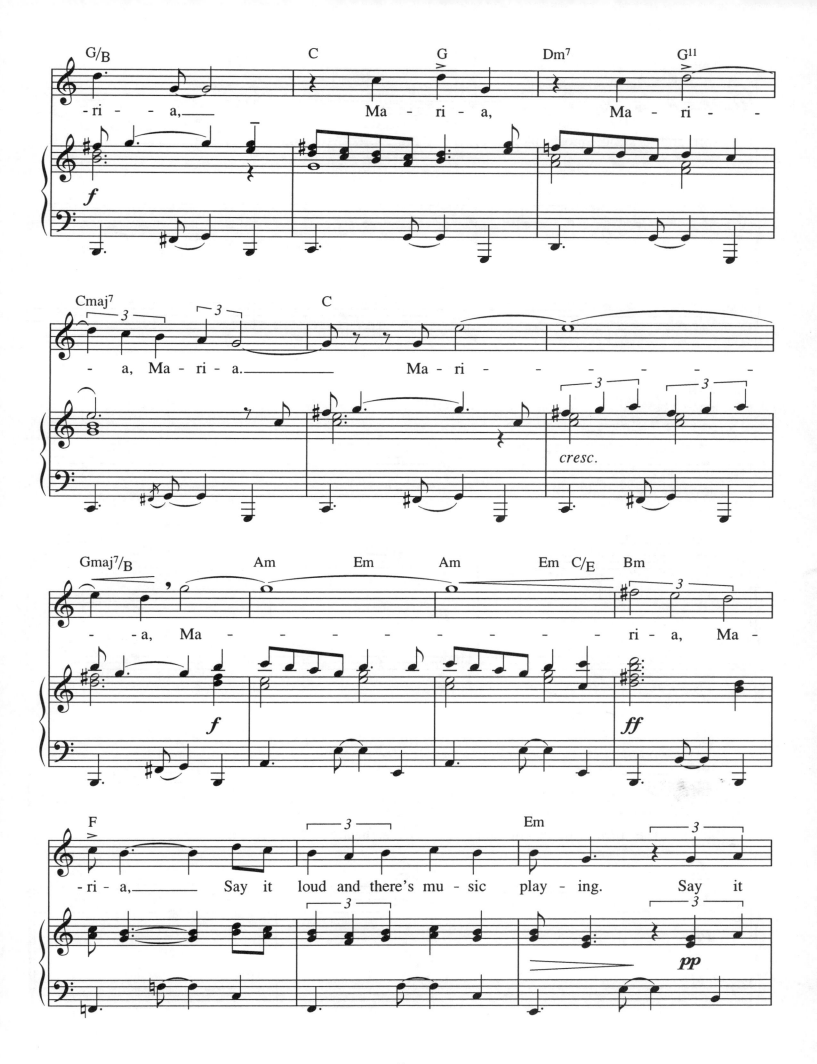

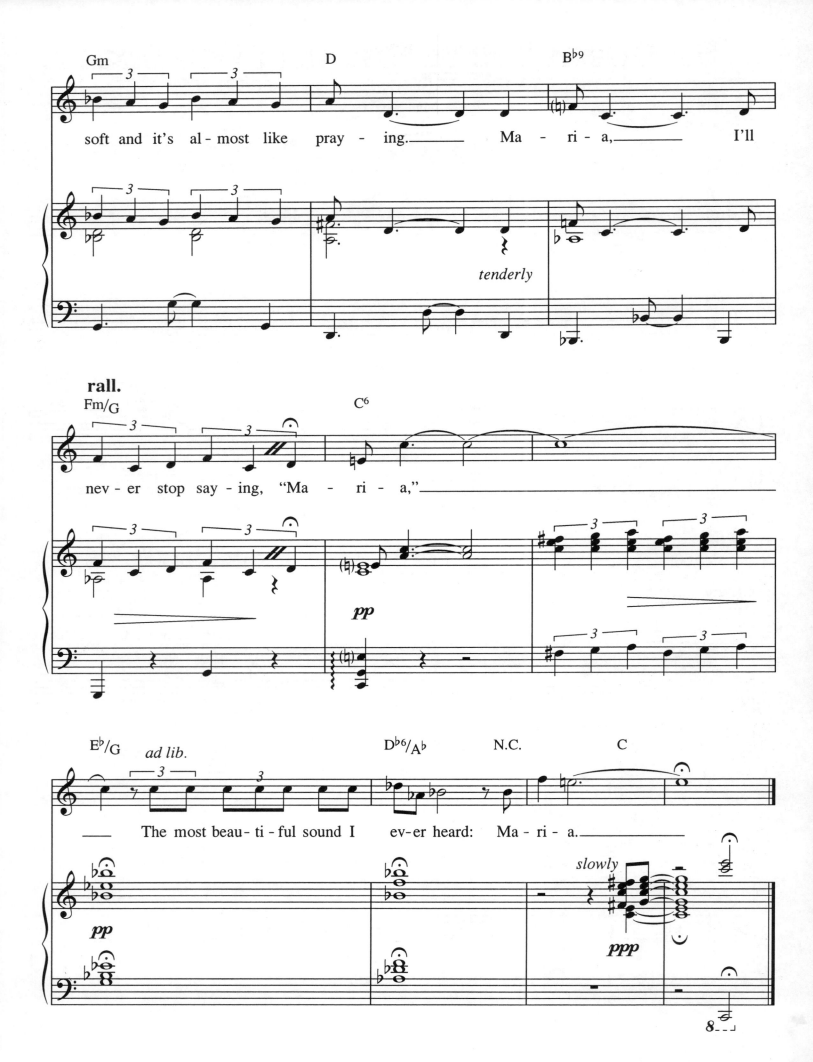

Sit Down, You're Rocking The Boat

Words & Music by Frank Loesser

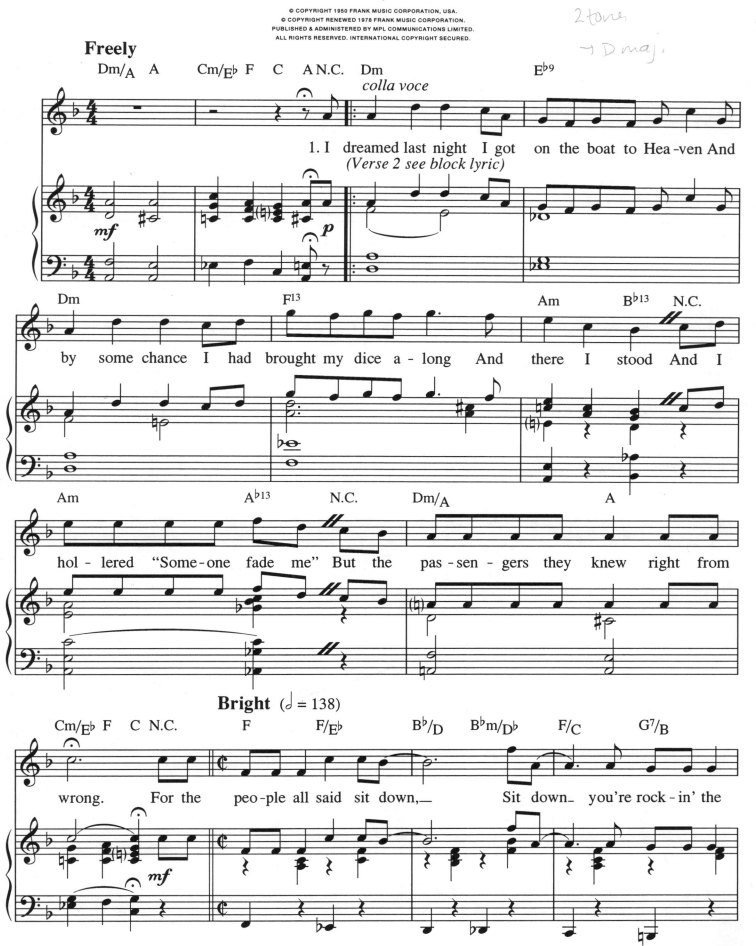

1. I dreamed last night I got on the boat to Hea-ven And
(Verse 2 see block lyric)
by some chance I had brought my dice a-long And there I stood And I
hol-lered "Some-one fade me" But the pas-sen-gers they knew right from
wrong. For the peo-ple all said sit down,— Sit down— you're rock-in' the

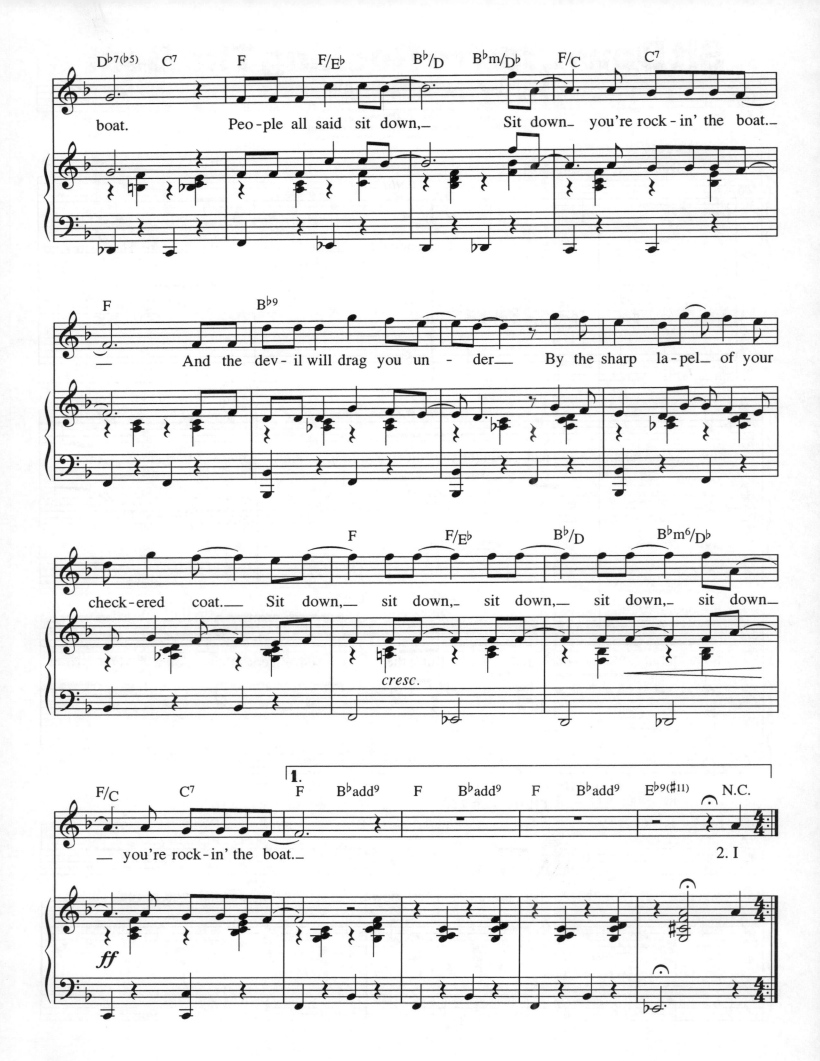

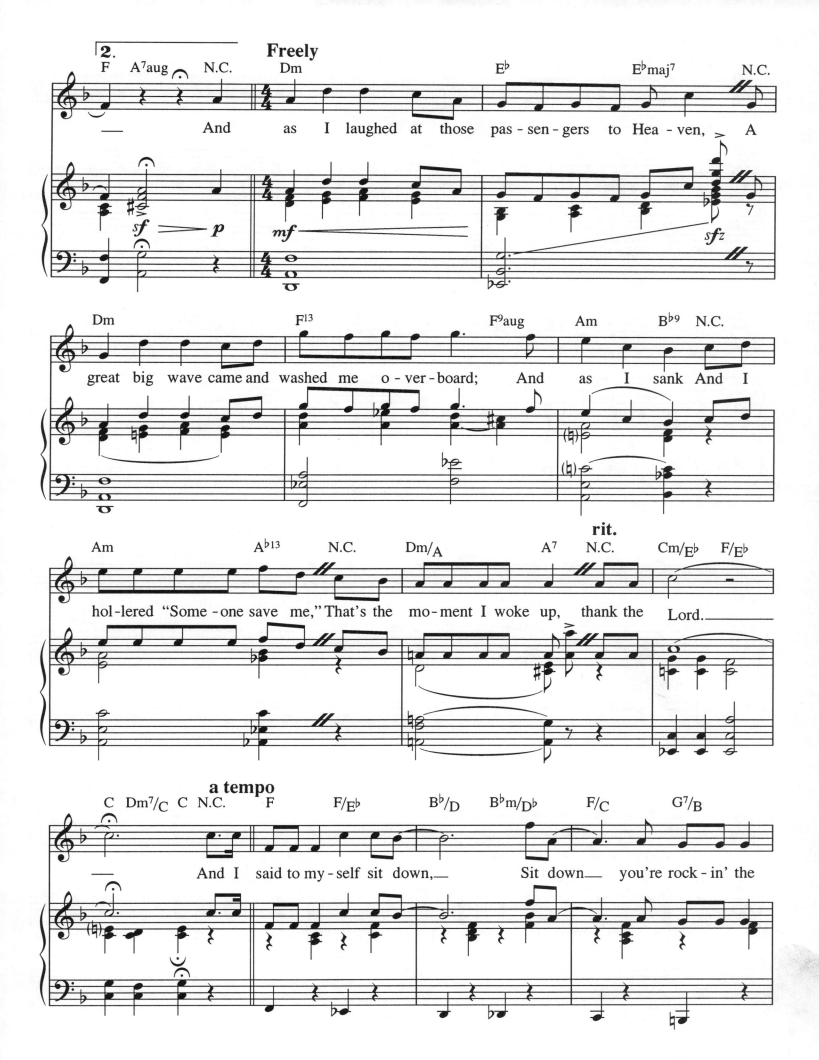

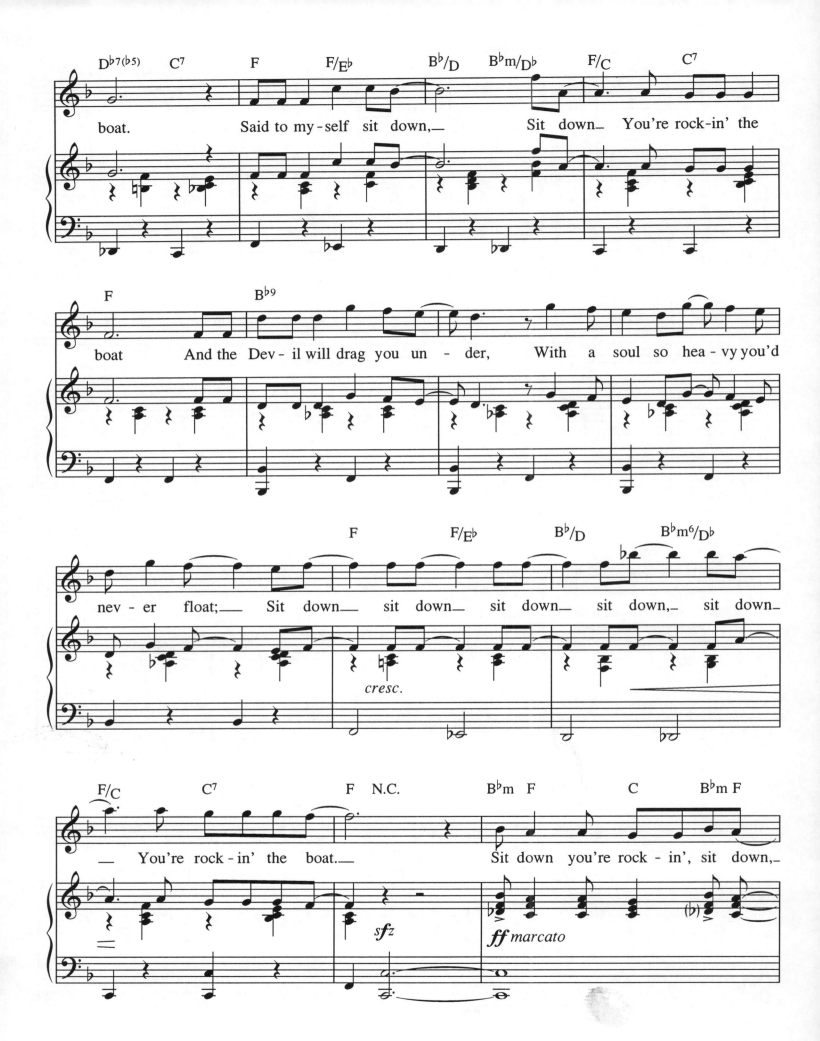

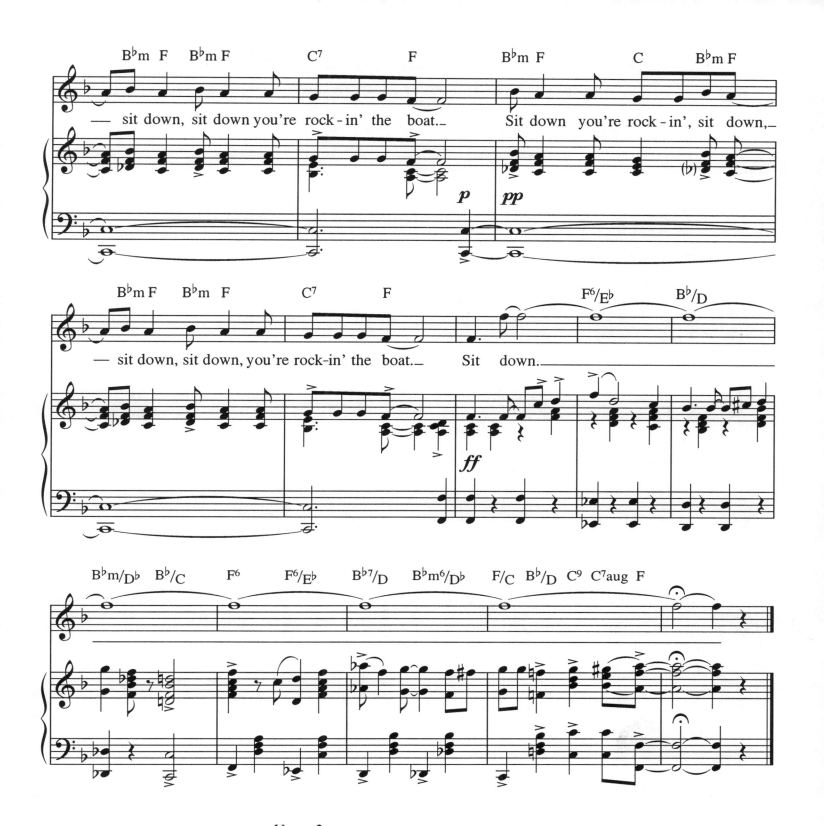

Verse 2
I sailed away on that little boat to Heaven,
And by some chance found a bottle in my fist.
And there I stood, nicely passin' out the whisky;
But the passengers were bound to resist.
For the people all said "Beware,
You're on a heavenly trip".
People all said "Beware,
Beware, you'll scuttle the ship.
And the Devil will drag you under
By the fancy tie round your wicked throat.
Sit down, sit down, sit down, sit down,
Sit down you're rockin' the boat".

Some Enchanted Evening

Words by Oscar Hammerstein II
Music by Richard Rodgers

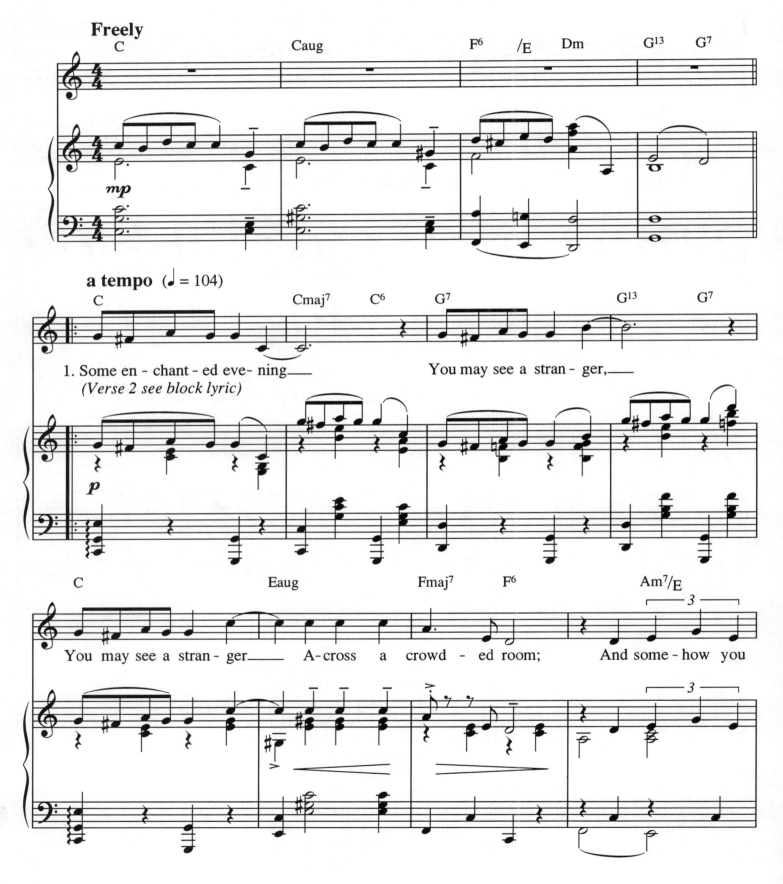

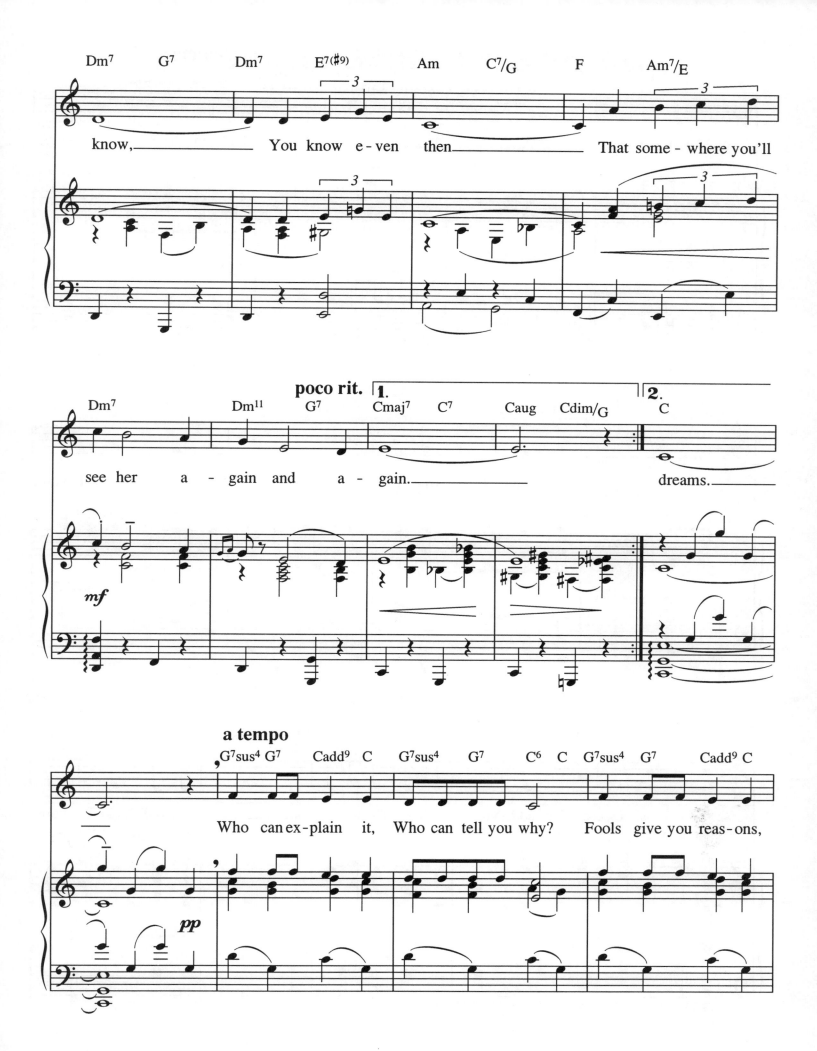

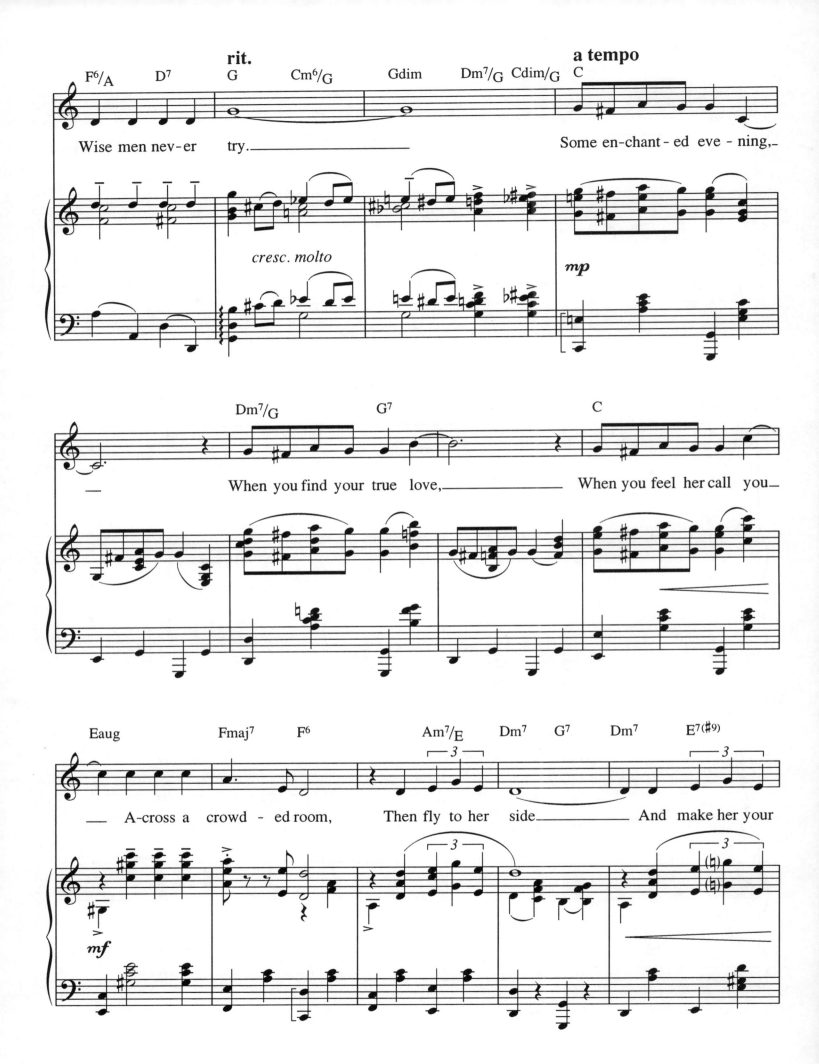

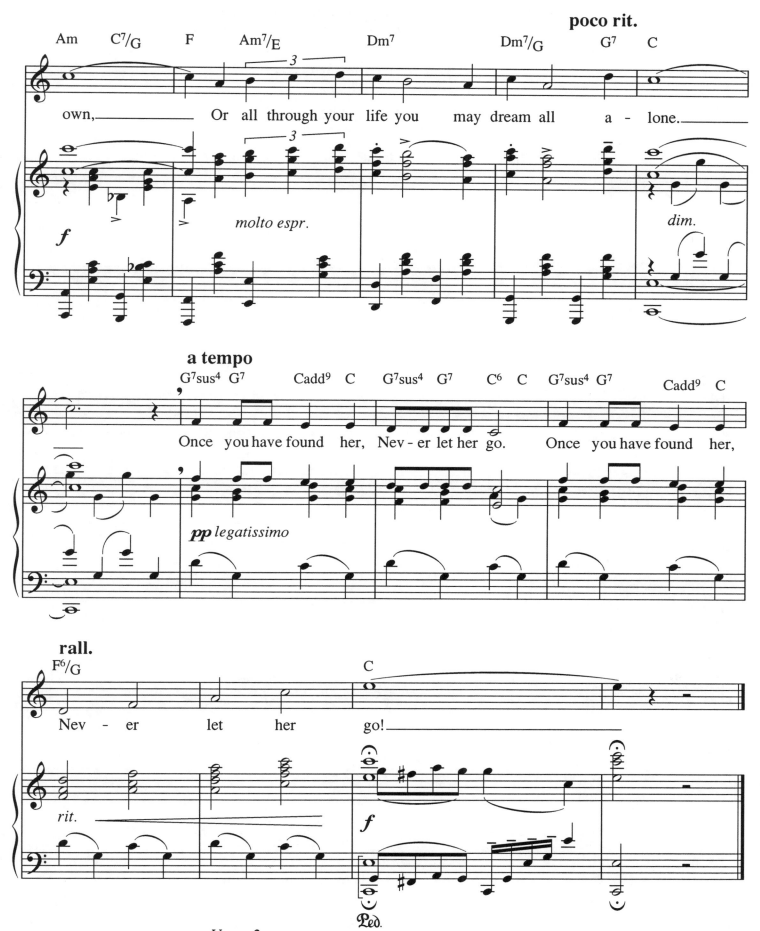

Verse 2
Some enchanted evening, someone may be laughing;
You may hear her laughing across a crowded room.
And, night after night, as strange as it seems,
The sound of her laughter will sing in your dreams.

This Is The Moment

Music by Frank Wildhorn
Words by Leslie Bricusse

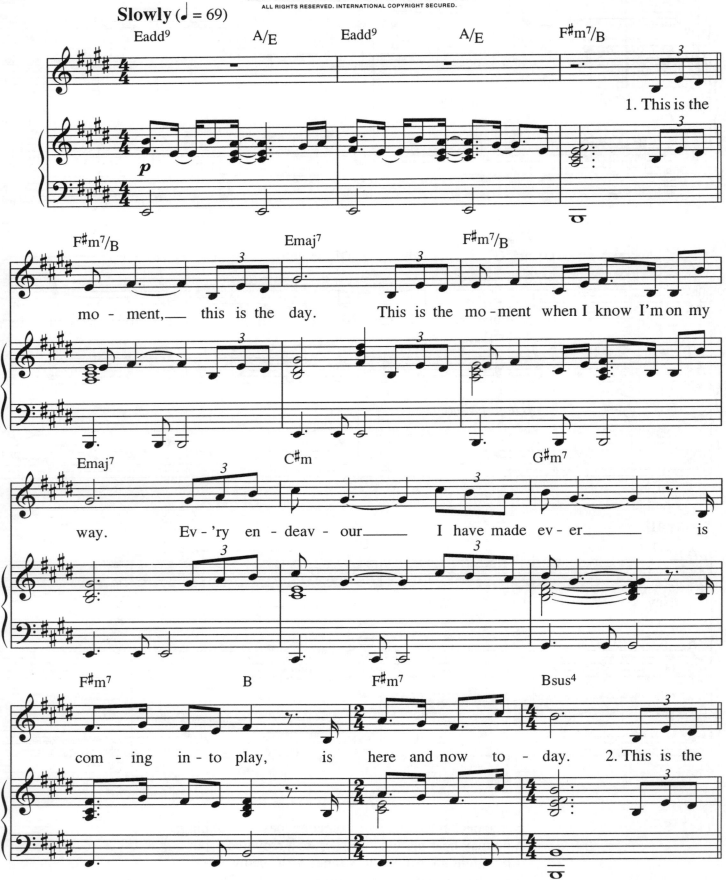

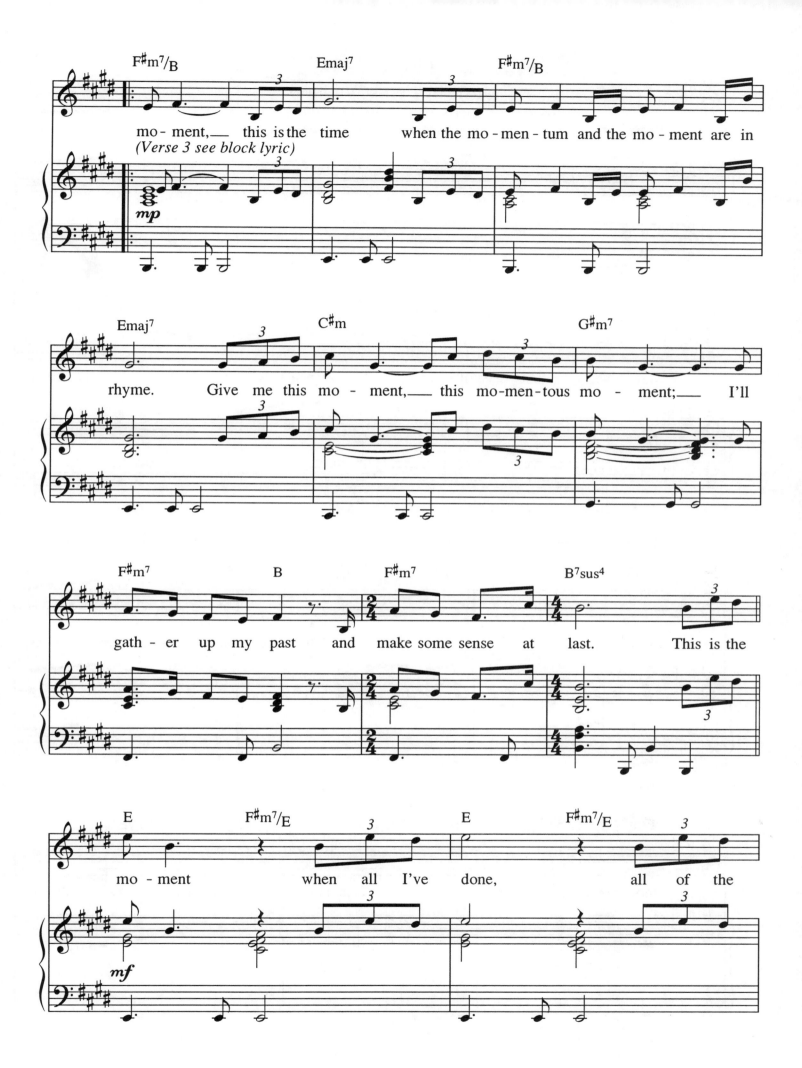

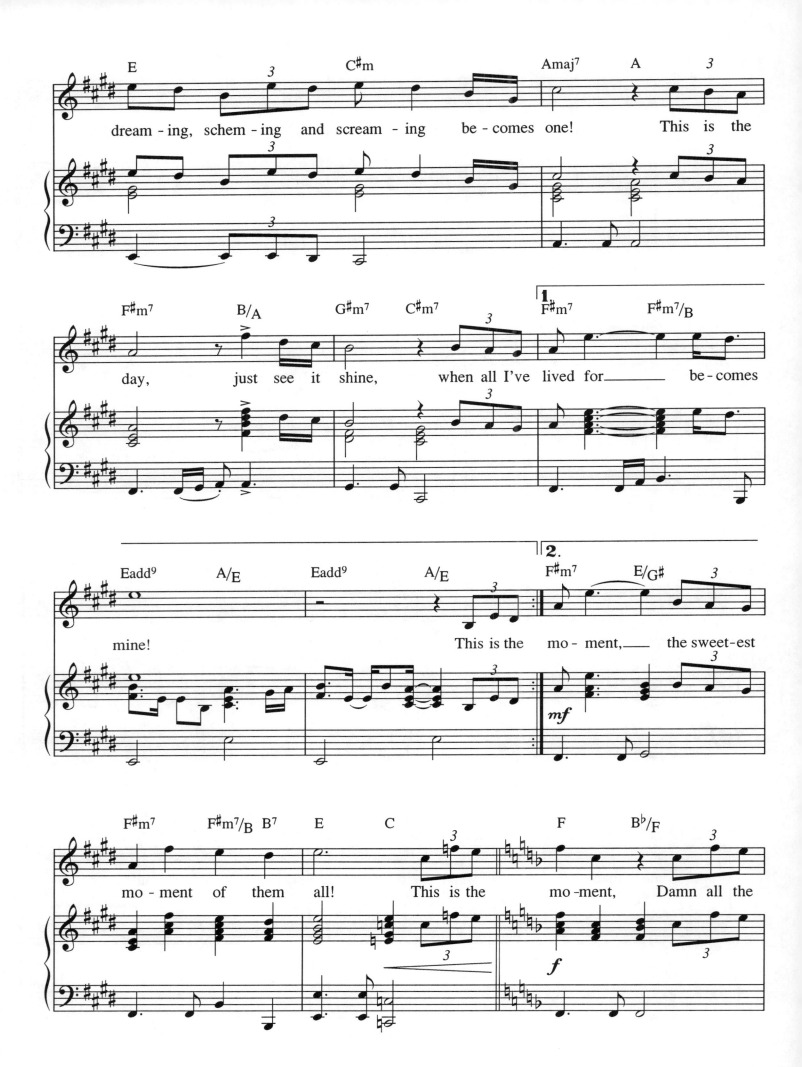

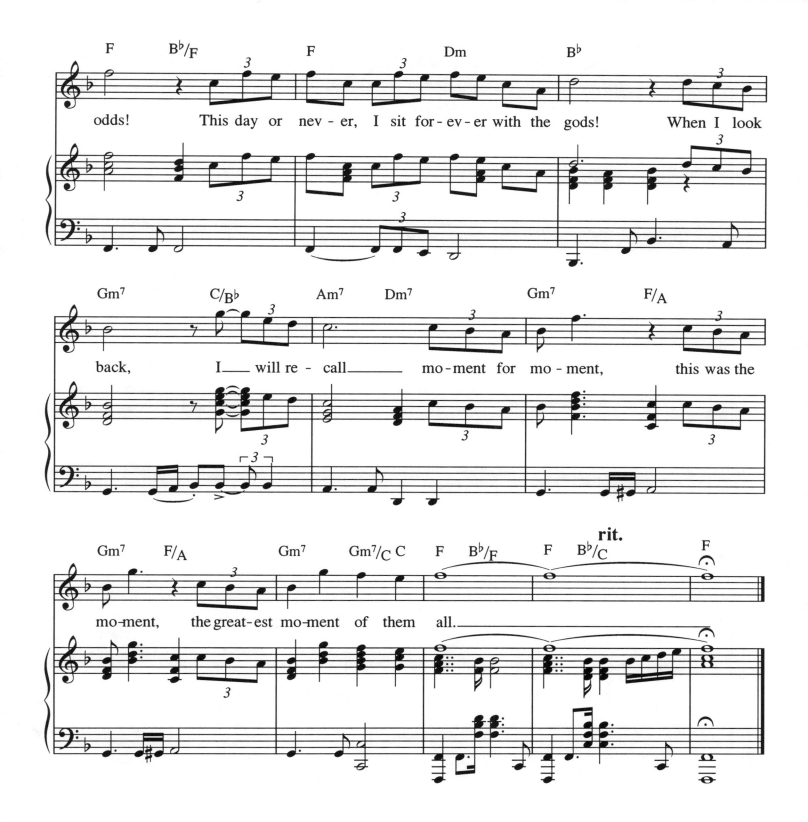

Verse 3
This is the moment, this is the hour
When I can open up tomorrow like a flower
And put my hand to ev'rything I planned to;
Fulfil my grand design, see all my stars align.
This is the moment, my final test.
Destiny beckoned, I never reckoned second best.
I won't look down, I must not fall.
This is the moment, the sweetest moment of them all!

You're Nothing Without Me

Music by Cy Coleman
Words by David Zippel

Moderately bright

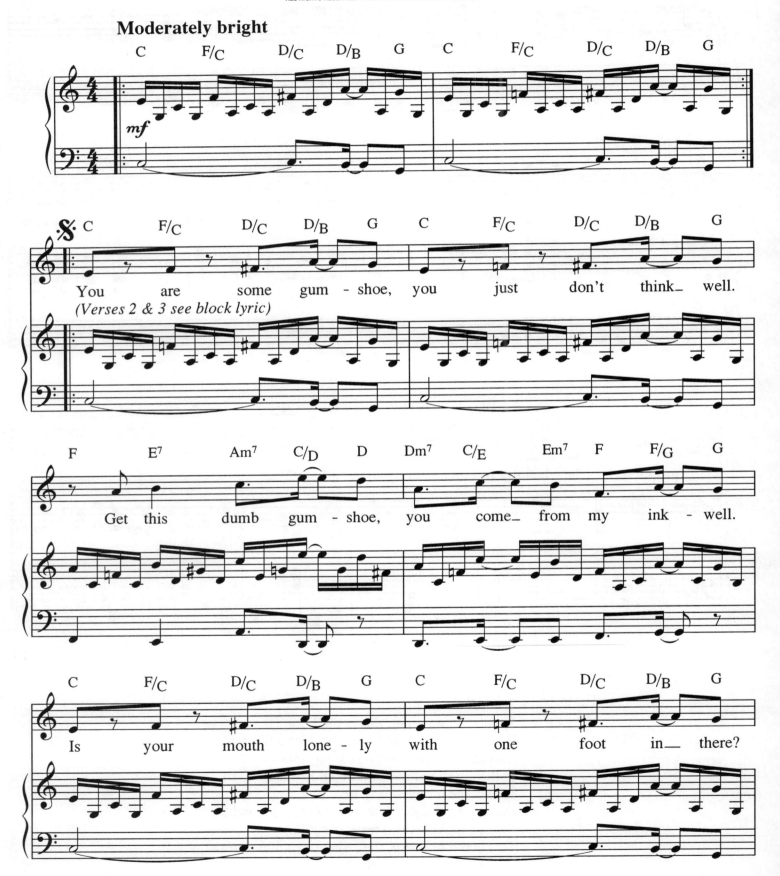

You are some gum-shoe, you just don't think_ well.
(Verses 2 & 3 see block lyric)

Get this dumb gum-shoe, you come_ from my ink-well.

Is your mouth lone-ly with one foot in_ there?

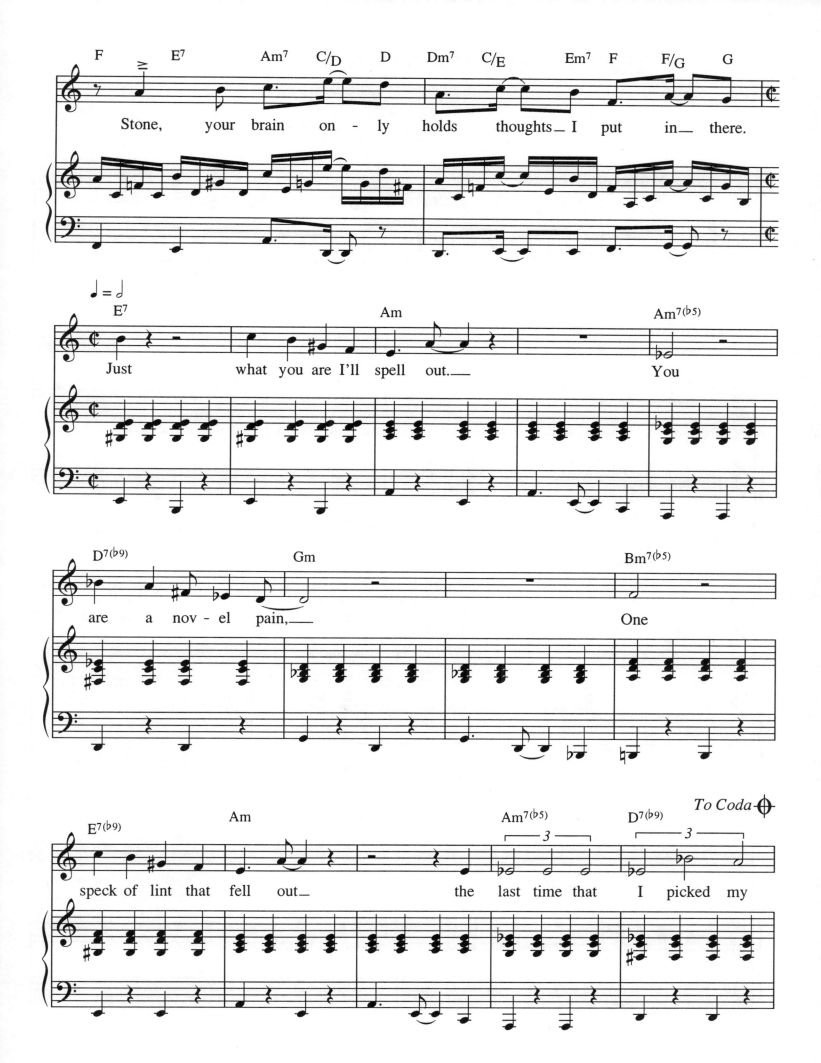

Stone, your brain on-ly holds thoughts—I put in— there.

Just what you are I'll spell out.— You

are a nov-el pain,— One

speck of lint that fell out— the last time that I picked my

To Coda ⊕

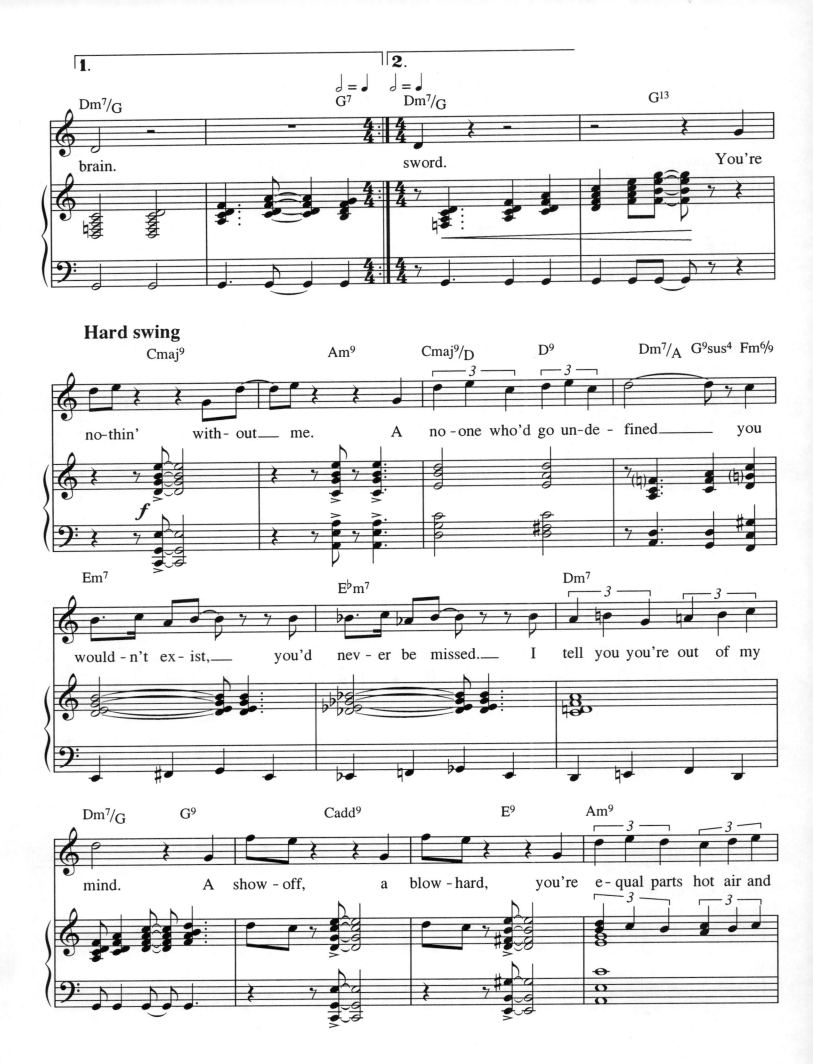

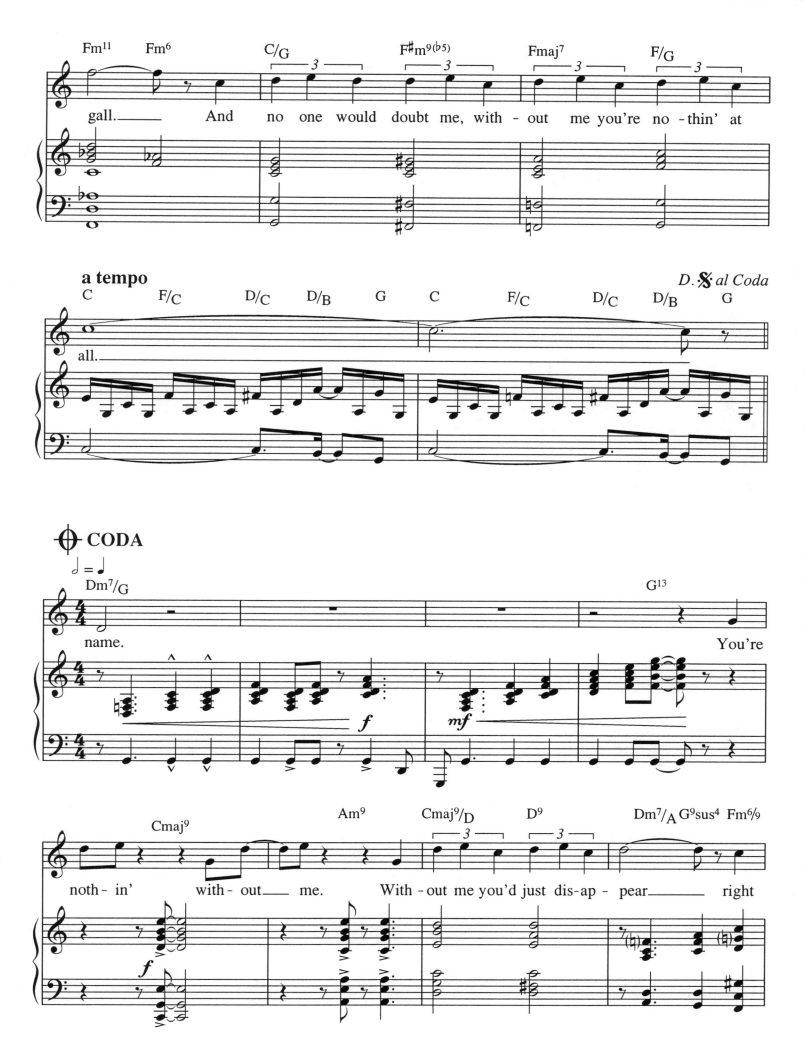

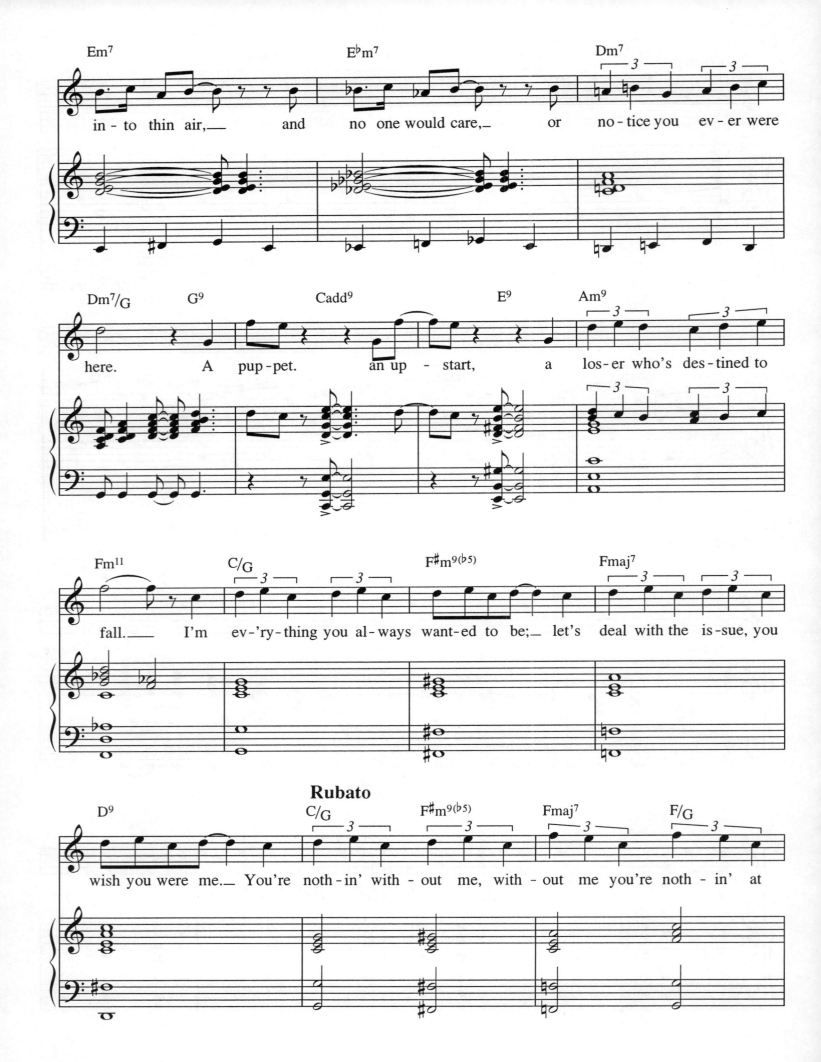

a tempo

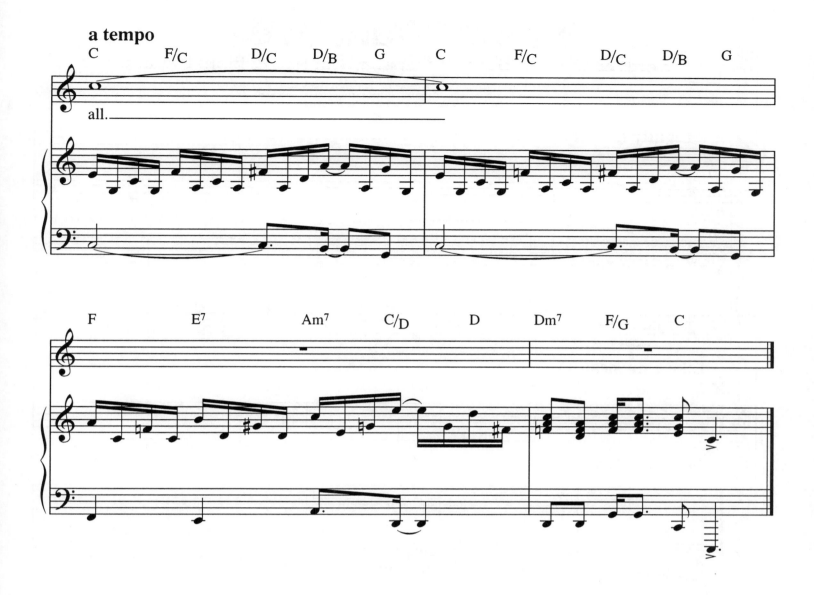

Verse 2
You are so jealous of my track record.
Tolstoy, do tell us your feeble hack record.
Your weak knees brand you soft and unstable.
One small threat and you fold like a card table.
You drool at my adventures,
Your broads in bed are bored.
Go home and soak your dentures,
Your pen is no match for my sword.

Verse 3
You're in my plot; I'm still your creator.
I call each shot; I'm your private dictator.
You are so thick you eat, breathe, sleep fiction.
I'm your meal ticket, knee deep in cheap fiction.
You gloating ignoramus,
You haven't any shame.
Hey I'm a famous shamus,
And most people don't know your name.

Where I Want To Be

Words & Music by Benny Andersson, Tim Rice & Bjorn Ulvaeus

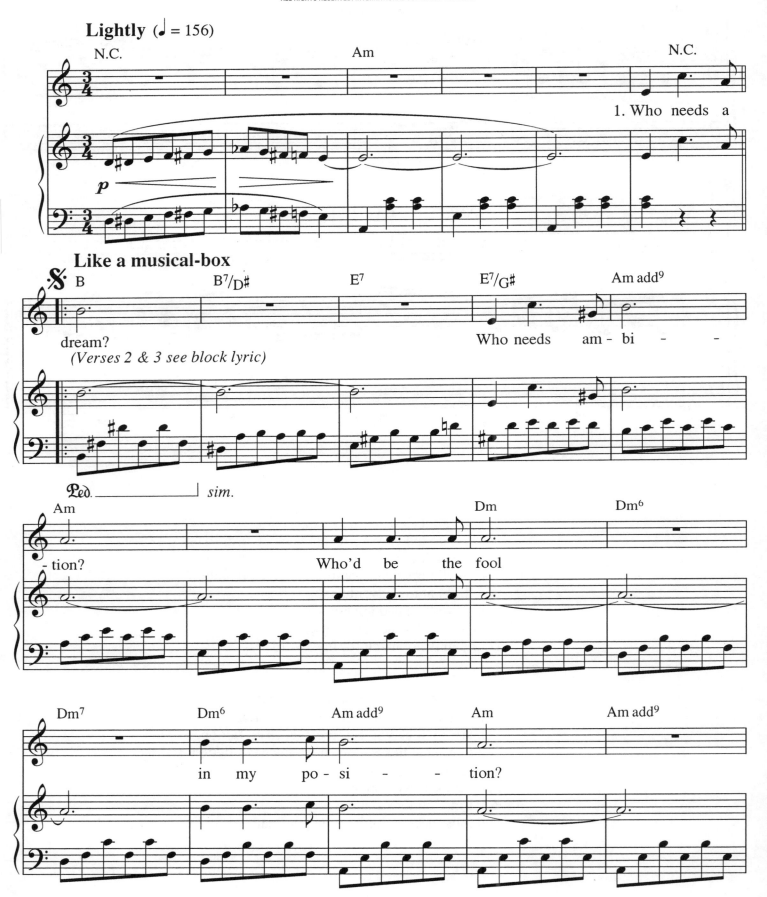

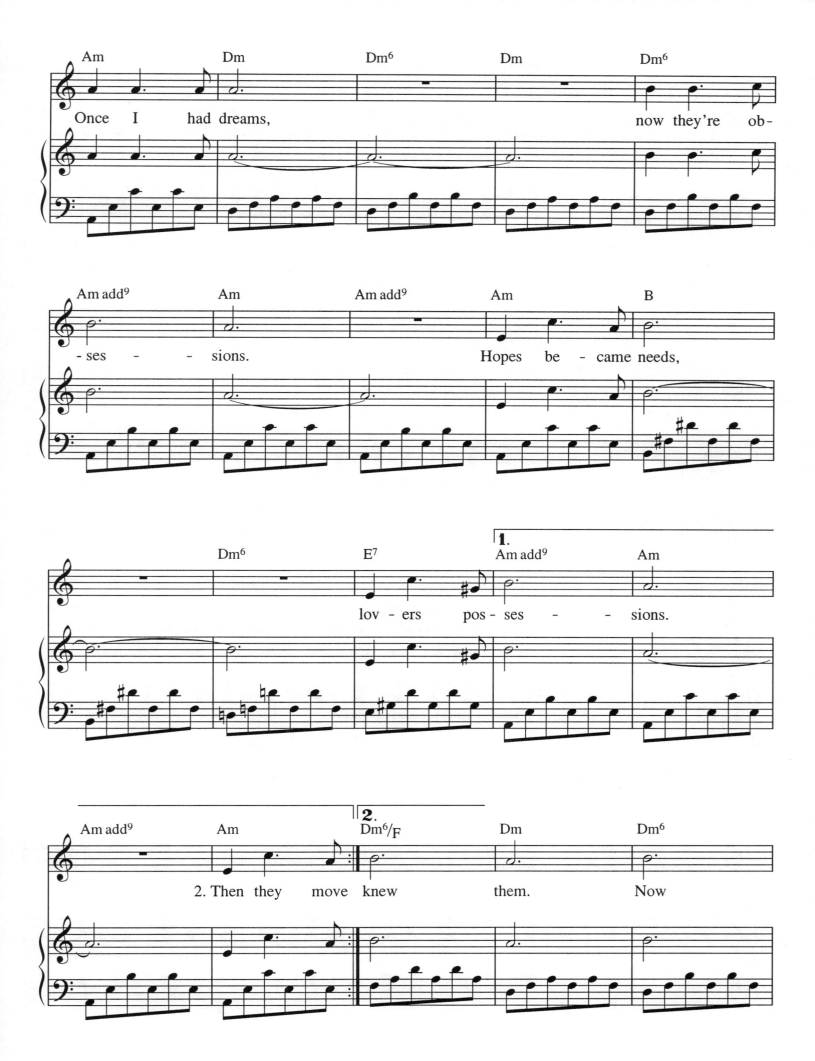

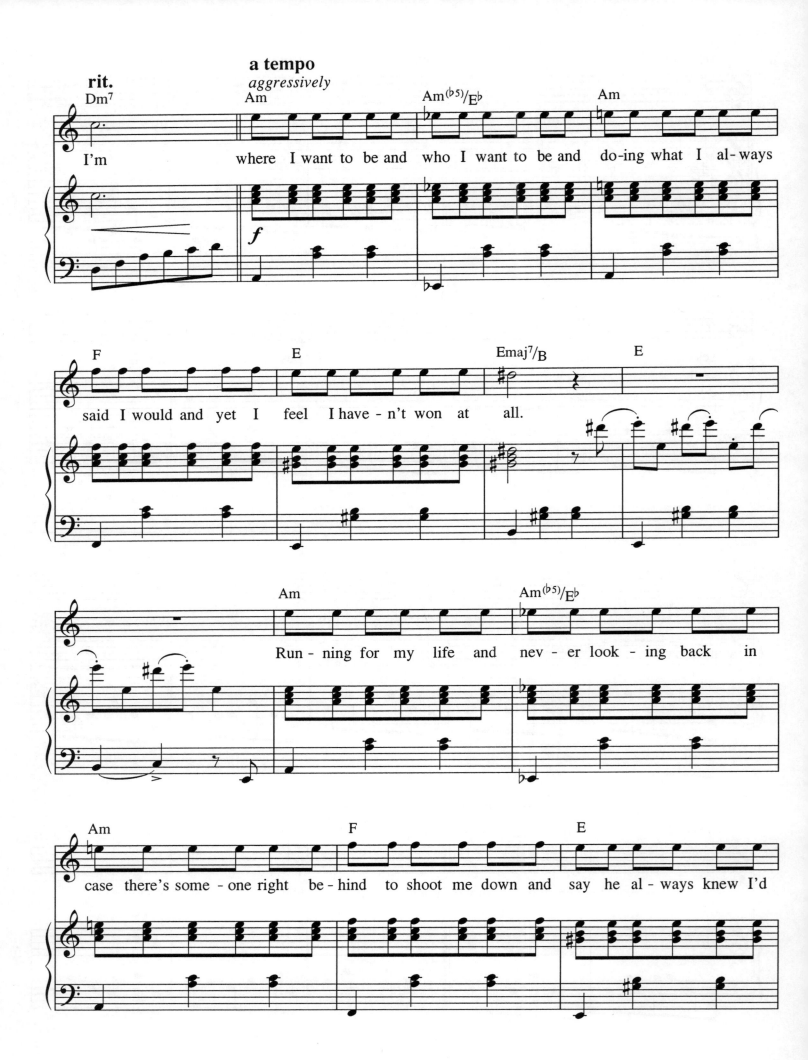

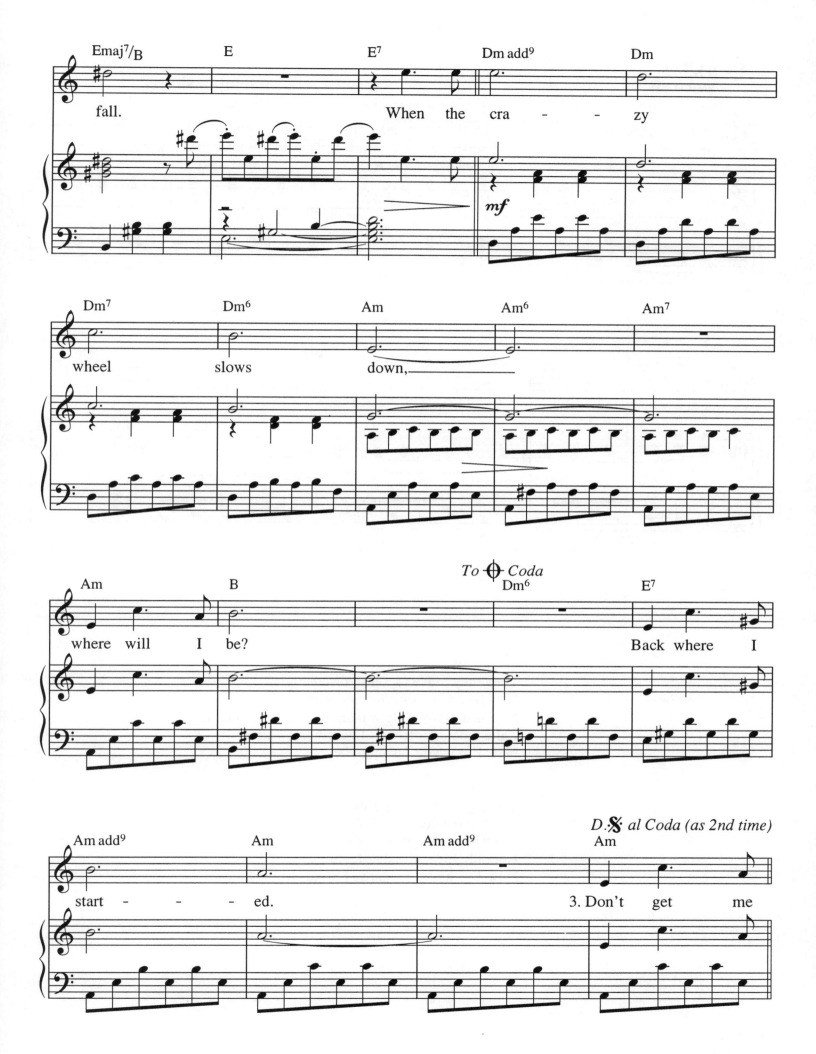

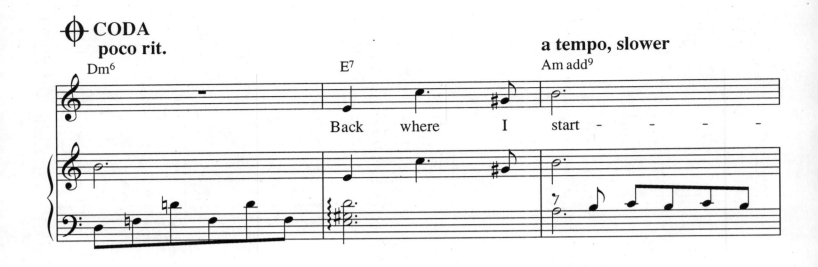

CODA
poco rit.

Back where I start

a tempo, slower

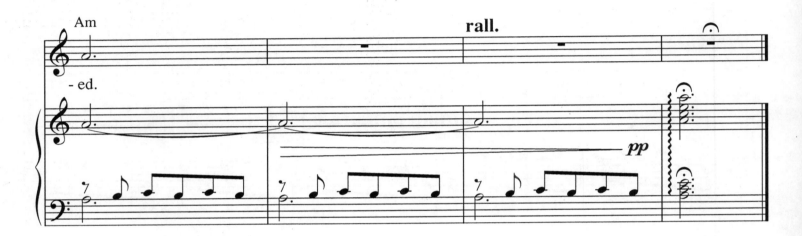

- ed.

rall.

Verse 2
Then they move in, oh so discreetly;
Slowly at first, smiling too sweetly.
I opened doors, they walked right through them,
Called me their friend; I hardly knew them.
Now I'm where I want to be, etc.

Verse 3
Don't get me wrong, I'm not complaining.
Times have been good, fast, entertaining.
But what's the point, if I'm concealing
Not only love, all other feelings?
Now I'm where I want to be, etc.

9/02 (45326)